# TACTICS
# OF
# SOCIAL
# INFLUENCE

**ALBERT MEHRABIAN**

*University of California
Los Angeles*

**PRENTICE-HALL, INC.**

*Englewood Cliffs, N.J.*

**PRENTICE-HALL SERIES IN CLINICAL AND SOCIAL PSYCHOLOGY
AND PERSONALITY**      Richard S. Lazarus, *series editor*

**© 1970 by Prentice-Hall, Inc., Englewood Cliffs, N.J.**

P-13-882159-3      C-882167-4
Library of Congress Catalog Card Number 76–106002
Printed in the United States of America
Current printing (last number): 10  9  8  7  6  5  4  3  2  1

PRENTICE-HALL INTERNATIONAL, INC., *London*
PRENTICE-HALL OF AUSTRALIA, PTY. LTD., *Sydney*
PRENTICE-HALL OF CANADA, LTD., *Toronto*
PRENTICE-HALL OF INDIA PRIVATE LIMITED, *New Delhi*
PRENTICE-HALL OF JAPAN, INC., *Tokyo*

71/ 16829

# CONTENTS

# *FOREWORD*

There has been a dramatic recent rise in interest in the principles of behavior modification. Perhaps one reason for this is the questionable success of the psychoanalytically oriented point of view in dealing with the garden-varieties of maladjustment, and a second is the inability of psychoanalysis to provide simple, concrete recommendations for dealing with unwanted behavior patterns. A therapeutic point of view whose principles could be translated into meaningful and understandable corrective actions for anyone regardless of his education and training, continues to be widely sought. To close this gap, Dr. Mehrabian has written in very readable form a "primer of behavior modification" called *Tactics of Social Influence*, for the student of psychology and the intelligent layman.

Although protagonists of behavior modification are a professional "minority group" at present, they have formulated a position which has achieved widespread attention and controversy among professionals, and they have industriously elaborated a view of psychopathology and treatment which they present as a "corrective" to the dominant psychoanalytically oriented outlook. Psychoanalytically oriented psychotherapists regard most "symptoms" as the product of inner problems of which the individual is largely unaware, and which are inaccessible to modification except through lengthy psychotherapy. "Symptoms" are thus seen as a result of neurosis; they represent a disorder of the total personality and they cannot be effectively and permanently eliminated without treating the neurosis itself. Behavior therapists, in contrast, argue that symptoms, or rather unwanted behaviors, are learned in the same way as any other habits, and can be likewise unlearned by the same principles. From this point of view, the "symptoms" of maladjustment do not, of necessity, have a deep, unconscious significance; therefore, they can be removed by concentrating on the situational conditions necessary to unlearn them.

To appreciate Dr. Mehrabian's book we need not get into the question of which of these contrasting positions is more correct. In all probability, both sides of the spirited debate are partly right, and the problem becomes one of defining when a symptom is part of an elaborate neurosis, and when it is merely an undesirable habit which needs to be eliminated. Moreover, the borderline between these two extremes is also probably quite hazy. Dr. Mehrabian has sensed the pessimism implicit in the psychoanalytic approach: the layman is essentially passive and helpless to shape his own behavior or that of those he loves or needs, because he cannot hope to understand the psychodynamics of this behavior without lengthy treatment. That is, the psychoanalytic premises do not lend themselves to the creation of a cookbook of things to do when behavior which should be altered is observed. On the other hand, behavior modification principles allow the ready formulation of a set of actions which can be taken to deal with unwanted behavior in oneself and others.

Although Dr. Mehrabian recognizes that there are dangers inherent in such an approach, he also richly portrays the basic principles of behavior modification, and shows how these may be applied systematically in a variety of familiar human contexts of maladjustment. He accomplishes this without unnecessary jargon and yet without

distortion of the basic principles of behavior modification. His book is at once a clear textbook of behavior modification principles, and a manual for the application of these principles in the form of concrete actions. As a result, two kinds of readers should be interested in *Tactics of Social Influence*, students of psychology (undergraduate and graduate) who want to learn about the rationale and techniques of behavior modification, and intelligent laymen who hope to influence the behavior of other people in the ordinary course of their social and occupational activity, and need to handle personal and family problems.

**Richard S. Lazarus**

*University of California, Berkeley*

# PREFACE

This book was written to bring together some ideas and techniques
emerging from recent psychological research bearing on social
influence. The focus of the volume is a series of methods which
are broadly termed "behavior modification." To discuss these
methods, we will cite some principles and then show how they
are applied to several classes of situations where change in one's
own or another's behavior occurs or is desired. Our examples,
for the most part, have been drawn from the common situations that
we all might encounter at some time in our lives. Illustrations
range from such simple things as improving one's own working
habits, changing a child's undesirable behavior, and training a pet,
and on to more difficult problems such as the management of
large groups of persons, the very subtle ways in which people

communicate their feelings and influence one another, the ways in which home environments can be designed to have the desired effects on eating, sleeping, or creative activities, or the elimination of tics and phobias.

I am grateful to the many students whose questions prompted this effort, and to Professor Tom Trabasso for his helpful comments on the manuscript. I am particularly indebted to Kathleen Dalzen, whose editorial efforts made this a book which could be deciphered in my absence.

**A. M.**

*The best way to eat the elephant standing in your path is to cut him up in little pieces.*—African proverb

ONE

# *FROM INTUITION TO PRINCIPLES?*

There is a kind of inertia in people's behavior that makes change difficult and distressing. It is easier to act the way we always have than it is to change our behavior, even though that behavior may be unsatisfactory and even troublesome.

A human being's ability to change his own behavior and to influence that of others is one of his most important tools for adapting to life situations; it comes into play in his private life, in his home, social, vocational, and political environments, and it has a tremendous effect on human relations. If one is unwilling or unable to realize his potential for change and influence, he is likely to experience frustration in his personal relationships.

1

Unwillingness or inability to change is due in part to the fact that when we *do* arrive at a common-sense or intuitive solution to a problem, it often ends in failure. So we find ourselves reverting to our old ways. In other words, this failure to find workable solutions can cause inertia. But why do we fail?

A major obstacle to changing behavior is the lack of guiding principles that are simple enough to be applied successfully in everyday problem situations. We lack such rules partly because we are somehow repulsed by the idea that our own behavior—or anybody else's—might be explained and compartmentalized by impersonal rules. Most of us have trouble discussing our methods for dealing with others; we may *feel* that a particular reaction will help solve a problem but be unable to describe any principle that led us to that conclusion. We tend to be skeptical of the suggestion that many behaviors could be predicted reasonably well or changed in terms of some set of rules. Our humanistic values have discouraged us from approaching the workings of our own lives and personal relationships as we approach inanimate objects. While we have established numerous principles for dealing with the technical aspects of our environment, we shy away from "rules" for coping with the more complex and mysterious realm of human interaction.

Most principles that can be systematically applied to induce change in human beings tend to be the exclusive domain of the professional psychologist and psychiatrist. But even professionals have been inclined to view the problems of change in terms that seem more mystical than scientific. For example, psychoanalytic training programs were originally organized on the assumption that the analyst must himself undergo psychoanalysis—a series of vaguely defined experiences that are expected ultimately to provide him with some very special skills or powers; he is supposed to be able almost unconsciously to communicate with his client, to intuit, and to interpret hidden conflicts that the client manifests in seemingly innocuous behaviors. The implication, then, is that to bring about a change in somebody else's behavior, one must be a very special type of person and then experience a prolonged period of specialized training. Thus the layman feels unequipped to convert the ideas and methods of professionals into practical solutions for changing his own or someone else's behavior.

In the last few years, however, the popularity of psychoanalysis and psychoanalytic therapy has been waning, at least among professionals, mostly because of recent psychological research that has shown that all problems are certainly not of equal difficulty; that all problems need not, indeed cannot, be solved by the same technique, such as psychoanalysis; and that problems can, if one is willing to go in that direction, be expressed in terms of the specific behaviors of the person himself or of those around him. In fact, some of the research findings are clear enough that most people could, with some guidance, take the principles and apply them effectively to most of their everyday problems, thereby dissolving much of the mystical aura surrounding problem solving.

On the basis of such recent developments, our present effort is designed to counteract (1) the widespread feeling that people's behaviors can't be categorized or made subject to "rules," and (2) the tendency to consider interpersonal problems to be too complex and confusing for the layman to deal with.

This book deals, then, with behavior modification. We will cite some principles and then illustrate their application to several classes of situations where change occurs or is desired. Our examples, for the most part, have been drawn from the common situations that we all might encounter at some times in our lives.

Problem situations seem to dominate our discussions since they illustrate most dramatically the need for change and the characteristic aspects of the processes involved. But our approach isn't entirely problem-oriented—most of the principles discussed can also serve to "make a good situation better." Illustrations range from such simple things as improving one's own working habits or changing a child's undesirable behaviors, to more difficult problems such as phobias.

The book discusses many interrelated techniques which are drawn from learning theory and research and are known generally as *behavior modification* (4, 6, 16, 36, 46, 61, 66). Thus, the approach that has been used throughout involves just a few basic concepts and the relationships among them, the understanding of which requires no prior knowledge of psychology. As the reader proceeds he will encounter analyses that are progressively more intricate, but each is nevertheless based on the same few essential concepts—concepts that are gradually elaborated to tackle increasingly complex

situations of social influence. Each concept is illustrated in a variety of settings to ground it effectively in the reader's own experiences and help him apply it meaningfully to his own particular situations.

The behavior modification approach differs in several aspects from the more familiar Freudian (15, 20, 51) and other related psychodynamic psychologies (52). One distinction is that it focuses on specific behaviors rather than unobservable internal processes and conflicts. It therefore includes procedures for attempting change which can be readily measured and assessed as to their effectiveness, whereas changes in internal conflict are more difficult to measure. In most instances the procedures are simple enough to be applied effectively by the nonprofessional, in contrast to the more exclusively professional application of psychodynamic principles. And most important, behavior modification differs from psychodynamic approaches in that it involves very few concepts that need to be understood and remembered before they can be applied. The reader is thus provided with (1) a broad set of guidelines for identifying recurrent patterns in his own or others' behavior, and (2) a set of rules and procedures for changing such behavior, which should help him avoid the intuitive trial-and-error methods for problem solving that are frequently time consuming and, worse, ineffective.

Finally, the approach offers somewhat of a challenge since the series of principles presented actually have unlimited application. They open the door to many avenues of exploration which a conceptually motivated reader may enjoy pursuing in his own life and his relationships with others.

The sequence of the materials presented generally reflects the increasingly complex steps one encounters in dealing with a situation which requires change. The first step in the attempt to influence behavior is, very simply, to define the problem. If "define the problem" sounds superfluous—an unnecessarily obvious beginning—you may find it interesting to observe for a time just how vague most people are when it comes to pinpointing their difficulties. A precise definition of one's problem is important because it provides a goal, a focus for one's efforts, which in itself helps to alleviate frustration. The second chapter of the book, therefore, deals with the definition of problems—problems that are brought on and perpetuated by behavior of the participants. In subsequent chapters principles are introduced one at a time and applied to several situations to show how each can influence certain behaviors.

Before going on, we must caution the reader to keep in mind the tentative quality of the proposed principles and techniques for understanding the processes of change in human behavior. In this field, as in any field of research that is still developing, we cannot attain certainty; we must maintain an accepting attitude toward new findings and developments.

Finally, we must mention the moral and ethical issues involved in influencing the behavior of others. The use and transfer of knowledge and skills is pertinent to every area of learning. There is always the chance, whether in science, business, or the study of human relations, that someone will choose to misuse the skills he has been taught. Is it therefore wrong to provide people with such knowledge? In our society we have resolved these fears somewhat through the development of ethical codes for various professions, designed to enforce integrity and discretion in the application of knowledge. We hope that the principles illustrated in this book will be used to improve, rather than exploit, the human environment.

# WHAT'S THE PROBLEM?

*Vark: I have so much trouble with my parents. They don't show enough respect for my opinions, they still treat me like a baby.*

In solving problems within ourselves and in relation to others, part of the dilemma we face is identifying precisely what is causing the difficulty and distress. Of course, people vary considerably in how vaguely or specifically they define their problems. Contrast Vark's statement with the following:

*Aard: My parents treat me like a child and question me constantly. "Where are you going?" "How much did you spend for this?" "Have you been studying your physics?" and on and on. Whatever I'm doing, they tell me how to do it better.*

Aard's description of his parents' demanding and irritating behaviors is far more specific than Vark's.

If we can find a way to expand the statement of a problem to a concrete list of the specific behaviors which constitute it, one major obstacle to the solution of the problem will have been overcome. In other words, the initial ambiguity with which most people analyze their interpersonal problems tends to contribute to their feeling of helplessness in coping with them. Knowing which specific behaviors are involved, and thereby what changes in those behaviors will solve the problem, provides a definite goal for action—and having that goal can lend a great sense of relief.

Let's begin this business of definition by examining two situations in which behavioral changes are desirable.

*Rachel: My husband is sometimes so rational, so unemotional, that he seems cold and cruel. This sort of attitude doesn't seem intentional, nor is it lasting, but when it does happen there is nothing I can do but hopelessly accept it while it lasts.*

*Reuben: I have two roommates and generally we get along pretty well, but one of them often wants to have things his own way and this becomes a problem in what would otherwise be trivial situations. For example, if I am cooking, he will be there with detailed instructions on how I should go about it. He decides, or tries to decide, when the apartment will be cleaned and who will do just what job. In a host of other circumstances, he often tries to impose his will on my other roommate and me, and the decisions he makes often seem arbitrary, without any particular reason or logic. Since he is our roommate and a good friend in many ways, we have been hesitant to approach him about this situation for fear of creating an atmosphere in which none of us could live comfortably. Certainly we will have to approach him someday, but since his tendency to issue menial instructions amounts almost to a passion, we do not see how it will do much good.*

There is a marked difference in these descriptions. From Reuben's statement it is easy to see which of the troublesome roommate's behaviors are a source of irritation and discomfort to the other two. For example, he told them how to cook and when to clean. If Reuben had said merely, "I have a roommate who really irritates us by being so overbearing and frequently imposing his will on others,"

the statement would have lacked enough detail to be helpful. As it was, his statement indicated more clearly how to proceed in changing the irritating behaviors. It was desirable, for instance, to discourage the roommate's unsolicited advice and to minimize the frequency with which he ordered the others to carry out household chores.

In contrast, Rachel said she sometimes found her husband unemotional and unresponsive, but did not specify the behaviors that were upsetting to her. If she had gone no further, it would have been difficult to proceed to a meaningful solution. She had to describe exactly what she meant when she called his behavior "unemotional." When she was encouraged to give very detailed illustrations, certain recurrent behavior patterns became apparent. For example, when she told her husband about a problem she was having with their child, she was hoping he would offer some assistance or moral support, such as, "We could take the baby along with us tonight." Instead, he often responded with an intellectual observation about child rearing. To Rachel, a more sympathetic response from him would have indicated more willingness on his part to help her out, to spend time with—and do more for—their baby. Again, the critical point was for her to elaborate specific examples and describe in each case exactly what she said and did and what he did in response. With these specifics, she was in a better position to focus on the behaviors that needed change.

The first step in the definition process, then, is to obtain an expression of the problem in terms of specific components rather than in vague generalities. (As already mentioned, it's surprising to note how many of us *do* stop at generalities.) After eliciting one detailed illustration, we request a second one, and then a third, and so forth, until perhaps half a dozen illustrations are obtained. Provided with such a set, we can then begin to see certain patterns, certain characteristic qualities in the behavior of the participants and in the qualities of the setting, all of which form the basis for understanding the difficulty. It is essential to draw out as many details as possible. More specifically, the common pattern to look for among the examples are (1) the undesirable behaviors which are associated with distress and which seem to be beyond the control of the persons involved, and (2) the implied direction of change, that is the implied desirable behaviors which would relieve the distress and frustration.

Below are three additional problem statements in which some of the too-general portions are romanized. You might try to determine what you could do to obtain more precise definitions.

*One of my relatives* acts indifferent *to most of us*. She is intro-verted and *doesn't try to extend her relationship with any of us. The more we try to extend friendship, the more she shuns our attempts.*

*I wish I could change the way one of my co-workers behaves toward me*. She picks on me constantly and acts superior to me. *I have told her (and so have many other co-workers) that I am not her servant, but it doesn't seem to have any effect.*

*The woman who provides me with room and board and care for my child does so not for the money I pay her so much as to help me out. As I am thus in her debt, I am powerless to protest the irritations I sometimes feel concerning some smaller* aspects of the care she gives my child. *Also,* her attitude toward me and life in general is very narrow, *but there is no point in trying to broaden her viewpoint, because she will never admit that she is wrong or change her views*. She's extremely neurotic *and at times seems almost to want to scare people concerning possible dangers. There is no way I can disagree with her be-cause of my position in her home.*

Some situations are hard to define because they involve unde-sirable but ambiguous reactions which one has difficulty explaining. Consider the case of Exergue, who stated, "I often feel nervous." How could his problem be defined more specifically?

*"How does it feel to be nervous?"*
*"I don't know, just uneasy and uncomfortable."*
*"How do you feel physically when you're nervous?"*
*"Well, some of my muscles get tense. . . . I get a kind of aching pain in the back of my neck . . . and when I'm very nervous I guess I even tremble a little."*

This gave us some idea about the physical aspects of his nervous-ness. Upon request for some specific situations in which he had been nervous, Exergue began, "Well, one time I went to a diner and ordered breakfast. I was in a hurry because I had to catch the bus, but the waitress delayed my order, stood around talking to others. . . . I was afraid of missing the bus, and I got very nervous. I said nothing to the waitress, but just sat there and waited nervously for my order."

This and several other examples began to indicate that Exergue used the word "nervousness" to describe his state after his needs had been overlooked or when he had been slighted or pushed around by others. In similar situations many people would be irritated or perhaps even angry, but Exergue experienced a vague "nervousness." This was an extremely uncomfortable feeling because when it suddenly descended upon him he felt helpless to cope with it.

Some of the other instances that Exergue cited as being disagreeable were occasions when his mother requested him to do errands or household chores that he didn't want to do and times when a co-worker delegated work to him but did not do his own share. Exergue felt helpless because he didn't know how to change the behavior of others involved in these interactions, nor how to react himself. Once we had helped him define the causes of his nervousness, he was better able to master it.

Once we have established the specific behaviors that need to be changed (increased or decreased) in a given situation, we can further clarify the nature of the problem by deciding just how severe each problem behavior is relative to the others—the second step in defining a problem. For example, if we conclude that a problem situation involves seven undesirable behaviors, those behaviors are ordered from one (most distressing) to seven (least distressing). With such an ordered list, we can go even further and estimate the needed increases or decreases in the "frequency" of each behavior. That is, we can estimate the number of times a behavior *actually* occurs, as well as how often we *want* it to occur during a given period of time. In computing this frequency, we need to choose a period of time (an hour, day, week, etc.) that is short enough to be convenient and long enough to be valid. For example, in estimating frequency of cigarette smoking, a period of one day would probably be the best measure because not much fluctuation is expected from one day to the next, while there can be a great deal of flux from one hour to the next. One person may smoke more heavily right after lunch or dinner. If he selects an after-lunch or after-dinner hour to estimate the frequency of his smoking, he will overestimate it; if he selects a morning hour, he will underestimate it. In his case, averaging over the entire day is more satisfactory since his fluctuations from day to day are less drastic. Certainly a week could serve as a valid time period, but it would take much more effort to establish a frequency estimate for a whole week; for that reason it is usually preferable to

select the shortest period which will provide a stable frequency measure—in this case, a day.

There are several reasons for ranking the troublesome behaviors in this way. First of all, experiments have shown that the least severe problem behavior is the easiest to change successfully. And success encourages perseverance—one is much more likely to continue to a more challenging difficulty if he's been able to "conquer" the first ones he faced. Also, the successful change of some less severe problem behaviors can frequently provide a person with necessary coping skills—a kind of "on-the-job training"—so that he is better equipped to deal with the more difficult stages of the problem when he finally approaches them. So, establishing an ordered list and attacking the problem in that order increases the possibility of success at each stage and the likelihood that a person will see a problem through to its finish.

What else contributes to the severity of the problem besides its distressing quality? One thing is the *frequency* with which it occurs and its "uncontrollability." While either a high frequency or an uncontrollable quality in a problem behavior can indicate severity, a combination of both points to pronounced severity.

Now contrast Robin, who complains that he *occasionally* feels rebellious at the idea of obeying orders (from parents, employer, teachers, etc.) with Hood, who finds it *constantly* distasteful to comply with anyone's requests. There are two aspects of Hood's problem that distinguish it from Robin's: (1) it occurs more frequently, and (2) it happens in a greater diversity of situations. This example illustrates how problem behaviors that occur frequently tend also to occur in more diverse interpersonal settings. So, in attempting to make a quick estimate of a problem's severity, we may often rely on its frequency or on the diversity of settings in which it occurs.

Now consider these cases: Mark says he tends to smoke only when under a great deal of pressure; April says she smokes almost constantly, irrespective of the pressure she feels at any time. May complains that she can't get along with her parents, although she has no real difficulties in other relationships; John complains that he can't get along well with most of the people who are close to him. Clearly, according to the criteria for severity, April and John have the more severe problems.

Most of the problems which we will consider in this volume will

be of moderate or low severity. They will be those that occur infrequently or in only a small segment of an individual's social life. In other words, the problems will be drawn from people who have sufficient coping skills in most situations, but who may have a special difficulty in a limited area of their interpersonal lives. Thus, when a friend complains that he has difficulty concentrating on complex and technical reading material but that concentration is not otherwise a problem for him, he presents the level of severity we will consider. But an individual who experiences a constant inability to concentrate, even when listening to others or watching television, has a problem of much greater scope and greater severity, a type only infrequently considered here since it could probably not be solved without professional guidance.

Let's take one last example, which illustrates all the steps in defining a problem:

*Melinda: One person in particular always forgets my name, and I happen to work for her. Considering she does not have that many employees, about eight, she could get my name straight. Instead, she calls me by the name of another girl who is totally unlike me in physical appearance. . . .*

Here one aspect of the problem is specified, misnaming. Upon inquiry we found that it happens about four times a day. The clear-cut aim, then, is to minimize this behavior from four to zero times per day. Melinda's statement of other parts of the problem continues:

*This lady is also very nosy and wants to know what I do on my off time. . . .*

Upon further probing it was found that "very nosy" meant the following:

*She asks me whom I go out with, how often I go out, where I go, how late I come home, and on and on. Also she asks me questions when strangers are around and embarrasses me, and besides that she detains me after work by wanting to talk to me about my personal life.*

In the second part of this situation she mentioned basically three undesirable behaviors: (1) being asked personal questions during

work, (2) being subjected to embarrassing questions when strangers were present, and (3) being detained after work to be questioned about her personal affairs. The average time per day when the employer asked questions during work was about fifteen minutes; embarrassing questions occurred about three or four times per week; and the employee estimated that her employer detained her an average of fifteen minutes a day. Each part of this problem involved minimizing the frequency and/or duration of the employer's behavior. Since differences in frequency were negligible and no one of the three behaviors was markedly easier to change than the others, the problem was approached in terms of distress. Melinda judged behavior (3) as most distressing to her, followed by (2) and then (1), so her initial efforts were directed at behavior (1), the least distressing, then at (2), and finally (3).

Through this definition process, then, not only was a rather vague situation reduced to a specific set of behaviors, but also the extent to which undesirable behaviors occurred and the desired direction of change was determined in terms of a frequency statement. Moreover, a "plan of attack" was devised in terms of the distressing quality of each behavioral component of the problem. All of these factors contribute to the whole definition of a problem. Needless to say, the problem is not yet solved, but at least a direction for the solution has been identified. To summarize, then:

1. *Define the problem by reducing an abstract complaint to a list of the specific troublesome behaviors involved. Do this by obtaining several illustrations of situations in which the problem occurs (the more details the better). Look for common patterns among these illustrations—specific undesirable behaviors and indications of what new behaviors are undesirable.*

2. *Determine each behavior's distressing quality, its frequency of occurrence, and its uncontrollability. These factors determine a problem's severity (44). One easy way to view this relationship is*

$$Severity = Distress \times Uncontrollability \times Frequency$$

*Obviously, if distress is zero, then there is no problem. But whenever some minimal degree of distress in any situation is multiplied by frequency, the severity of the problem increases, especially when high frequency and uncontrollable quality are combined with distress.*

3. *Using the above equation, rank the problem behaviors relative to one another, from least to most severe.*

In subsequent chapters we will see many examples of ways to identify the specific behaviors in a given problem and to order these behaviors in terms of severity. There are some additional aspects to consider before the definition process is complete—what, for instance, maintains the undesirable behaviors in any given problem situation? Such matters, too, will be gradually elaborated in following chapters.

# *REWARDING*
# *"GOOD MISTAKES"*

## REWARD, PUNISHMENT, AND
## BEHAVIOR CHANGE

You have carefully defined the problem.
Now comes the hard part: how do you go about bridging the gap
between what your problem situation is *now* and what
you would ultimately like it to be? Some answers may be found
in the principles of learning. These principles are based on
experiments that explored the conditions under which an individual
replaces old behaviors with new ones, or simply acquires new
ones. They are therefore most relevant to our consideration
of behavior modification and social influence.

The area of learning contributes a major concept for explaining
change—*reinforcement*. There are two categories of reinforcement,

positive and negative. Broadly speaking, positive reinforcement means rewarding a person for exhibiting a specific behavior. Those experiences or things that are intrinsically satisfying, such as the gratification of basic physical needs (hunger, sex), are obvious positive reinforcers. There are other weaker reinforcers—doing something for another which he likes, for example, or giving him an opportunity to do something he enjoys. When a man buys his wife her favorite flowers or takes his son to the movies, he is behaving in a positively reinforcing way. Although he may not actually be thinking about reinforcing some specific behavior of his wife or child, he nevertheless is effecting change in some behavior of each one.

Negative reinforcement is punishment for exhibiting a certain behavior, and it ranges from painful physical stimulation and deprivation to weaker reinforcers such as verbal criticism, hostility, or simple expressions of dislike.

Experiments have shown a consistent relationship between reinforcement of behavior and the subsequent frequency with which that behavior occurs (17). The shorter the delay in positively reinforcing a behavior after it occurs, the greater the *increase* in the frequency of that behavior. Similarly, the shorter the delay in delivering a negative reinforcement, the greater the *drop* in the frequency of behavior (2). Some very precise information has been obtained about how closely in time reinforcement must follow a behavior in order to be effective (17, 56). For our purposes, we need only note that, in general, the sooner a reinforcement can follow an act, the greater its effect.

As we stated above, a behavior tends to be repeated more frequently after it is positively reinforced and less frequently after it is negatively reinforced. In other words, there is experimental justification for our common-sense assumption that a person who is rewarded for something he does will be more likely to do that thing again, and that he is less likely to repeat behaviors for which he has been punished.

In choosing reinforcers, we must consider an individual's likes and dislikes. To a child who loves Walt Disney movies, going to see "Bambi" can be rewarding and, if one chooses, reinforcing. If he likes candy, receiving a chocolate bar can be reinforcing; if he likes baseball, being taken to a World Series game could be a positive reinforcer. To an adult, sincere compliments about his character or his looks can be reinforcing. Success at work can be reinforcing, as

can an increase in pay or a bonus. In short, effective reinforcers are simply the things any given person would like to have or be able to do. Will the same things be reinforcing to everyone? No more so than the same things are equally desirable to everyone.

If there are two desirable rewards that can be given, the more reinforcing one can be determined simply by allowing the person a choice and observing which one he chooses or, given more time, which one he chooses to carry out first or more often (50). In other words, rewards can be ordered in terms of their reinforcing strength by asking the person to order his preferences. In this way we might discover, for instance, that a child would most prefer to go to the movies, next to play in the park, finally to have some candy.

Sometimes we may have only vague ideas about what kinds of rewards will be desirable to an individual. In such cases simple questioning often provides some answers. One could obviously ask a child, "What would you like to do?" or, "What are your most favorite things?" Adults can be asked similar questions, or they can be asked for a list of favorite things. Once a person tells of his preferences, we can order them in terms of their importance to him and thereby derive a list of possible reinforcers.

It is extremely important to select reinforcers whose effectiveness does not diminish with repeated use, because in order to influence behavior the reinforcer needs to be used repeatedly. Food, for one, is a reinforcer whose effectiveness diminishes rapidly. When a child is reinforced with a candy bar for the tenth time, his preference for it, relative to other things that he might find reinforcing, drops drastically, and the candy thus ceases to be a very effective reinforcer. In contrast, the repeated use of very small amounts of candy as a reward might not detract substantially from its reinforcing quality. The entire class of so-called "social reinforcers" (expressions of liking, appreciation, and encouragement, which may be communicated either verbally or nonverbally) also has a tendency to deteriorate with frequent use, particularly with adults. So if we followed every occurrence of someone's desirable behavior with a smile or pleasant comment, it's likely that he would cease to appreciate our tactics before long—as with too much of any good thing, it would be taken for granted. Of course, one way to avoid this problem of diminishing effectiveness in any situation is to vary the reinforcers used.

Another thing to keep in mind in using reinforcers is to select, among several similar ones, those over which one has the most con-

trol. So, in a home where it would be unrealistic to keep food under lock and key, food would not be an effective reinforcer because it is already relatively accessible to a child. But in a school setting where food is not generally available to children, it can be used very effectively as a reinforcer. In one possible training program, the children would receive no breakfast prior to coming to school. Being thus hungry during the early hours, the teacher could use food as a reinforcer for training socially desirable behaviors in the children. The mild state of deprivation would make food highly reinforcing, and since the available food would be under the teacher's control, she could use it to systematically reinforce behaviors of her pupils. Deprivation has been suggested as a good reinforcer in many other situations—hospitals, prisons, or any setting that permits a high degree of control over the basic reinforcers available to inmates or patients.

The effectiveness of reinforcement, that is the lasting value of the change induced by it, may also vary according to the *schedules of reinforcement* used (17). Suppose it is desirable to increase the frequency of a behavior and that an effective reward has been found for the person who produces that behavior. It would then be necessary to decide *how often* to reward the behavior to best obtain the desired result.

In psychological terminology, *continuous reinforcement* means to reinforce a behavior every time it occurs. When a wife responds with warmth and affection every time her husband brings her flowers, she is reinforcing his flower-buying behavior on a continuous schedule. *Partial reinforcement* generally means to reinforce a behavior only after particular occurrences (47). A special instance of partial reinforcement is *fixed ratio reinforcement*, in which the ratio of nonreinforced to reinforced occurrences is constant—the behavior is reinforced after a fixed number of times it occurs, say every third time. In real-life situations, fixed ratio reinforcement could be illustrated by an elevator salesman who receives a commission after each four elevators he sells. Every fourth occurrence of selling an elevator is reinforced on a fixed ratio schedule. With this schedule, it is typically found that immediately after reinforcement there is a brief pause before the person being reinforced resumes his activity at the same rate as before reinforcement. In other words, our elevator salesman would probably take it easy for a day or so following the bonus payment before wholeheartedly resuming his work.

A more interesting and frequently seen version is *variable ratio reinforcement*, in which the ratio of reinforced to nonreinforced occurrences varies—sometimes a behavior might be rewarded after five occurrences, at other times after two. Consider, for instance, the results of spiking the ball when playing volleyball. If the ball lands as intended, leaving the opponent unable to return it, then the spike would provide positive reinforcement. But if the ball lands in the net or outside the court, it would be a nonreinforced or negatively reinforced behavior. For a moderately good player, chances are that he executes a successful spike about half of the times he tries. Getting a traffic ticket is another example—only occasionally does a policeman stop us for a driving error. Gambling is still another illustration, and the persistence of those who gamble is testimony to the strength of these schedules. Winning a bet, the positive reinforcement, occurs very seldom but nevertheless seems to be a strong enough reward to encourage continued persistence.

One important thing distinguishes fixed ratio from variable ratio schedules: with fixed ratio reinforcement, one knows precisely when reinforcement will occur and can anticipate it. As we noted with the elevator salesman, one who is reinforced on this basis tends to pause after reinforcement before resuming his original rate of behavior. Since with a variable ratio schedule one doesn't know when reinforcement will occur, he will produce the reinforced behavior at a more consistent rate, without pauses. This would suggest that a variable ratio schedule is the one to use to elicit a steady and stable performance in another's behavior.

Other reinforcement schedules are oriented to time rather than number of trials. For instance, the pattern of feeding a pet once a day and always at the same time illustrates a *fixed interval* schedule, whereas feeding him at different times with unequal intervals between feedings illustrates a *variable interval* schedule. If your mail is delivered at a different time each day and you have no way of knowing exactly when it will come, your trips to the mailbox will be reinforced on a variable interval schedule—sometimes you will receive payoff and other times you will not.

The variable ratio and variable interval schedules are quite similar and are frequently hard to discriminate (47). When the behavior being reinforced is a discrete action which is frequently repeated, then occasional reinforcement seems like a variable ratio schedule. In contrast, when the behavior is a continuous action, intermittent

reinforcement seems like a variable interval schedule. For example, if a man is fly casting and occasionally catches a fish upon casting his line, he would be rewarded on a variable ratio schedule; but if he is just sitting in a boat on the lake with his line dropped over the side, then an occasional bite would seem more like a variable interval schedule. Another difference between variable ratio and variable interval schedules is, again, that the variable ratio prompts a more frequent response.

Further, for a fixed total amount of reinforcement, a variable ratio schedule is more effective than a continuous or a fixed ratio schedule, because it serves to induce a longer lasting change in the frequency of the reinforced behavior. What does this mean? Let us say a child is given a dime after he completes every page of a reading assignment (continuous reinforcement schedule). A second child is placed on a variable ratio schedule in which the average frequency of reinforcement is one out of three times. To make the total amount of reinforcement for this second child equal to that of the first, he is given thirty cents every time he is reinforced. If the children continue for about ninety pages with their corresponding schedules, they will both earn nine dollars. But even with total reinforcement being the same for both, the experimental findings suggest that the child who was trained with the variable ratio schedule will continue with his reading and will ultimately read more than the one who was trained with a continuous reinforcement schedule (17, 56).

Why is the variable ratio schedule more effective? One reason is that the person being trained is not certain when he will receive a reinforcer. Consequently, when reinforcement ceases, he is not sure if there will be no more reinforcers or if there is simply an extraordinarily long delay. This uncertainty makes him persist longer in producing the behavior, even though he is not reinforced. Another practical reason for using a variable ratio schedule is that it is not necessary to be present at all times to observe and reinforce, as it is when a continuous reinforcement schedule is employed; the variable ratio schedule also requires fewer reinforcers, which is helpful especially if the particular reinforcers selected tend to lose their luster with repeated use.

Finally, the variable ratio is the most subtle of the various schedules. At times it is better that a person not make an explicit connection between the reinforcer he receives and his performance of specific behaviors. We hope to show some very legitimate bases

for deliberately reinforcing behavior, but many people nevertheless object to the idea of being controlled or manipulated by another person, even if the change can be beneficial and despite the fact that social influence is a common aspect of social interaction, intentional or otherwise. The connection between reinforcement and the performance of certain behaviors is far more obvious with a continuous reinforcement schedule.

In general, then, where necessary, a reinforcement schedule might start with continuous reinforcement, shift, as soon as possible to a variable ratio schedule, and gradually increase the proportion of nonreinforced to reinforced behavior. In this way, at final stages of training, the changes can be obtained with a very small amount of reinforcement.

One other relevant term we need to mention is *extinction*, which is the return of a behavior to its original or prereinforcement level, or the gradual elimination of a new response (behavior change) through removal of the reinforcers. Examples may help to illustrate: Little Polly likes to pull on the leaves of her mother's rubber plant. Her parents decide to punish her for damaging the plant by slapping her fingers. A respected friend sees them punishing Polly for touching the plant and suggests that "frequent physical punishment can inhibit spontaneity in children." The parents point out that their punishment had been effective because Polly now only rarely touches the plant; however, they decide to stop slapping her fingers. To their chagrin, they find that Polly gradually resumes her old habit of pulling on the leaves of the rubber plant. Her newer response, not touching the plant, was extinguished when the negative reinforcer ceased.

A second example relates to the development and elimination of a child's tantrum behavior. Some parents who are busy or under great pressure from other sources may tend, because of preoccupation, to overlook or ignore their children when they are "behaving," being forced to attend to them only when they misbehave or throw a tantrum. The parents' attention, since it is hard to come by, is reinforcing for the child and thus helps increase the frequency of, for instance, tantrums. Occasionally, the parents may even try to ignore the tantrum, but they may have to give in to the child just to stop the disturbance. In this case the tantrum is reinforced on a variable ratio schedule. Experiments have shown that a child's tantrum behavior can be extinguished by parents who stop attending to (and thereby stop reinforcing) such behaviors (64).

A final consideration about reinforcement is how to balance the use of (1) positive, (2) negative, and (3) positive-plus-negative reinforcers. We will generally emphasize the application of positive rather than negative reinforcers, for several reasons. First, the effects of punishment are far more complex than the effects of reward or positive reinforcement. Punishment involves a variety of side effects which complicate a situation. For example, experimental findings have shown that when a person is punished in a given situation, although the behavior being punished decreases in frequency, there also develops a tendency to avoid the situation (2). Thus a child who is punished in the classroom may begin to play hooky or feign illness to avoid returning to the painful situation.

Punishment may also result in aggression toward the punishing agent. Suppose a teenager is being punished and retaliates aggressively with the result that the punishment stops. The teenager's aggressive retaliation is reinforced because it is instrumental in stopping the negative reinforcement—the punishment. Thus, even if aggressive retaliation of this kind is only occasionally effective in stopping punishment, aggressive responses will be reinforced and will become more frequent.

It is interesting to note that this type of learned aggression is also supplemented by a reflex-like response which experimental studies have shown to occur quite automatically and indiscriminately whenever an organism is subjected to pain. For instance, animals placed in a cage suddenly attack each other when they are shocked by a current passed through the cage floor. This automatic aggression is vented toward anything or anybody in the immediate vicinity of the organism being punished (2). Such aggressive responses following punishment are of course another reason that punishment is undesirable for use in social situations.

Although punishment can generally be avoided in influencing another's behavior, there are times when it becomes necessary. For this reason let us briefly note that under the following conditions, punishment *can* successfully and permanently suppress the occurrence of a behavior (2): (1) When the person being punished can in no way avoid the situation, (2) when punishment is sufficiently severe in quality and is introduced and maintained at the same level of severity (rather than being introduced at a low level and gradually increased in intensity), and (3) when the punishment is administered on a continuous schedule of reinforcement immediately after the

undesirable behavior occurs. As we shall see later on, however, the most effective use of punishment occurs when a person is simultaneously positively reinforced for some alternate and more desirable behavior.

Among the characteristics of punishment mentioned above, the most important seems to be its severity. Punishment of moderate severity does not produce lasting changes, whereas very severe punishment, administered on a continuous schedule, can and does. Our discussion of phobias in a later chapter will help explain this exceptional finding.

Still another form of punishment in social situations is merely the withholding or withdrawal of positive reinforcers and rewards. In one study, teenagers who were playing pool in a recreation room were punished for undesirable social behavior (quarreling, bumping one another, using abusive language) by being immediately removed from the recreation area and forced to wait alone in an isolated booth for fifteen minutes (60). This procedure, generally referred to as "time out," was found to be quite effective in minimizing undesirable behaviors in the recreation area and could be equally effective in any such situation.

The withholding of positive reinforcers, especially positive social reinforcers, is a frequent means of social control which most of us use intuitively (ignoring someone who is talking to us, not smiling when we greet someone). Systematic use of this technique in psychotherapy is illustrated by a situation in which the nurses on a ward ignore the "crazy" jumbled talk of a schizophrenic, attending to him only when he makes "normal" conversation. Such a technique, withholding attention, can minimize the frequency of the crazy talk. Even more importantly, when the mild punishment of withholding attention is combined with positive reinforcement of more desirable behaviors, even stronger effects can be obtained. The same patient will rapidly give up his crazy talk and increase his normal conversation if it is being reinforced with cigarettes, food, or anything else he especially enjoys.

Although punishment is sometimes appropriate and effective, it is still preferable to rely on the use of positive reinforcers in most instances, as follows. To "change a person's behavior" in a given situation means to induce him to replace one of his activities in that situation with another behavior. So in general, behavioral change involves diminishing the frequency of one action and increasing the

frequency of another. In fact, change can often be conceptualized as occurring along a continuum, with the undesirable behaviors, those to be diminished in frequency, assigned to one end and the desirable behaviors, whose frequencies are to be increased, assigned to the other end. Thus, the process of change is a movement from one end of this continuum to the other.

Two examples will show how this works. Beanie is a child who is uncooperative at times—he does not listen to his parents, refuses to help out with household chores, etc. Implicit in the formulation of change in this case is the building of cooperative behaviors on Beanie's part. His continuum would show a high frequency of uncooperative behaviors and very low frequency of cooperative behaviors at one end, and a high frequency of cooperative behaviors and low frequency of uncooperative behaviors at the other end. Obviously, then, increases in cooperative behavior tend automatically to force decreases in uncooperative behavior, and vice versa. Given that fact, and knowing the desired direction of change, it would therefore be possible to accomplish the desired change either by focusing primarily on a decrease of the undesirable behaviors or on an increase of the desirable behaviors. To decide to use primarily positive reinforcers would mean to focus on an increase of Beanie's desirable behaviors rather than a decrease of his uncooperative ones.

A second example is Alphie, the "silent husband," who hardly ever discusses things with Bet, his wife. She construes his silence as coldness, lack of affection, and unwillingness to share his problems and concerns with her. Alphie's continuum would be formulated with a high degree of silence and low frequency of conversation about his life outside his home at one end, and at the other end, a low frequency of silence and a high frequency of such conversation. Now it is clear that inducing Alphie to talk more about what happens at work or what happens in his contacts with others during the day would automatically diminish the frequency of his silence. Here again then, focusing on those behaviors whose frequency should be increased requires only positive reinforcers. The alternative procedure in both cases would be to diminish the undesirable behaviors through the use of negative reinforcers, a distinctly different approach.

Unfortunately it is not always possible to use only positive reinforcers with humans. There are certain situations in which the behavior being changed is so destructive and the amount of damage to oneself or others so great in only a brief period of time, that

gradual change by reinforcement of desirable behaviors to replace the destructive one is simply not fast enough. In cases where there is a time pressure then, it becomes necessary to use both negative and positive reinforcers simultaneously, as follows. Negative reinforcers are used initially to bring about a sudden drastic limitation in the frequency with which the destructive behavior occurs. Positive reinforcers are used at the same time to bring about more desirable behaviors. As an example, in some extreme cases of autism a child might claw at his cheeks, eyes, ears, etc., causing a great deal of physical damage to himself in a short time. In such a case the hospitalized child is frequently bound to a bed, thus completely disabled and prevented from hurting himself. But tying a child to his bed in no way promotes a constructive change. As an alternative, he is untied and given freedom to move and play except that through mild shock (administered via light electrodes which are attached to his arms) he is severely punished for reverting to his previous behaviors, such as any movements of his arms toward his face. He actually has considerable freedom of movement and is provided with a variety of toys to play with. Since there is a possibility of eliciting a large number of behaviors that are not self-destructive, positive reinforcement can be used to increase and maintain these other more desirable behaviors, which incidentally counteract the destructive ones. In the meantime, shock continues to be available for curtailment of destructive behavior. This case then illustrates the joint application of severe punishment, to quickly lower the frequency of destructive behavior, with positive reinforcement of alternate and more constructive behaviors for the child.

To summarize, in the majority of cases where it is necessary or desirable to change another's behavior, it is possible to rely primarily on positive reinforcers. When positive reinforcers are used in this way, they serve to increase the frequency of desired behaviors, thereby automatically decreasing the frequency of the undesirable behaviors. The remaining cases require simultaneous use of positive and negative reinforcers, as described above. The joint use of positive and negative reinforcers is effective in bringing about a desired change in such situations faster than could be achieved with positive ones alone. Finally, exclusive use of negative reinforcers at any time is generally discouraged—they are less effective and can create many troublesome social and ethical issues.

You will recall that in Chapter II (p. 8) we mentioned two criteria

to look for when analyzing a problem situation: (1) the undesirable behaviors which are associated with distress and which seem to be beyond the control of the persons involved, and (2) the implied direction of change, or the desirable behaviors that would relieve the distress and frustration. Given the concepts of reinforcement, let us now add three more steps to help with further refinement in problem definition: (3) the reinforcers present in the situation which might be helping to maintain or even increase the undesirable behaviors, (4) other available reinforcers in the situation which might help to increase the frequency of desirable behaviors, and finally (5) the agents who might be used to administer these reinforcers. This chapter will include numerous examples of how reinforcers may be identified as part of the pattern in problem situations.

To simplify matters somewhat, we have given names to the basic characters in our discussions. *Ragent* will identify the person serving as the Reinforcing AGENT, the one who initiates and reinforces changes in another. The PERson Being INfluenced will be known as *Prebyn*. Both names will be used throughout the remainder of the book so the reader can quickly identify the roles of the parties in the interactions.

## SHAPING

One of Skinner's major contributions is his detailed description of the steps whereby reinforcers could be used to change the frequency of behavior (56). These techniques are subsumed under the concept of *shaping*. To illustrate, suppose it is desired that a child be neater than he is. Should his mother wait until he has tidied his room to her satisfaction and then reinforce him, or should she initiate the change by altering the standard of her expectations? Experimental findings suggest that it would be most effective to proceed through a series of steps, positively reinforcing those behaviors which more and more begin to approximate the desired end product. To put it another way, one should positively reinforce his "good mistakes." Thus, any behavior that is slightly more tidy than usual should be reinforced, but behaviors that are at his characteristic level of untidiness, or lower, should not be. Untidiness to his mother may constitute not making the bed, not putting clothes away in the closet, not picking up toys, and being generally sloppy at the table. Some of these problems have several components; for example, being sloppy at the

table may include all sorts of individual troublesome behaviors. If we were to observe any one of these irritating behaviors closely, we could specify a habitual level of untidiness in terms of number of offenses per day. There would be a fluctuation about this habitual level of course—on certain occasions there would be less untidiness than on others. In shaping for tidiness, any improvement (a relatively lower frequency of untidy behaviors) would be reinforced immediately after it is exhibited, such as immediately following a meal at which the child has been slightly less sloppy than usual. The parents should ignore (reinforce neither positively nor negatively) those occasions when his habitual level of sloppiness occurs or when he is even more sloppy than usual. Having reinforced the child a few times for being slightly less sloppy, the parents can then raise their standards and require even more tidiness before reinforcing. In this way the desired goal will be gradually attained.

One can perhaps see from the above example that keeping track of an intricate and extended shaping program could be much simplified by a careful recording of the gradual changes in the desired behavior (the one being manipulated) and the reinforcements given for those changes. Such a record can help determine, in accordance with the selected schedule, when to or when not to reinforce. We must know the exact frequency with which a certain behavior occurs before we can determine how to shape it. Keeping such a record provides realistic feedback; a picture of one's accomplishments and failures is thus an integral part of shaping techniques.

The use of shaping does not automatically exclude problems in which behaviors are abstractly defined. For example, we might wish a certain person were more conscientious. To be "more conscientious" is an abstract summary of several problems involving specific behaviors. The use of shaping techniques relies on clear-cut definitions of an abstract issue in terms of its specific behavioral components. Therefore, if one wishes someone to be more conscientious, he must first define exactly what behaviors he would prefer that person to exhibit in different situations. Once those behaviors have been defined and quantified as to the frequency with which they already occur, a basis exists for employing shaping techniques. Other forms of this same problem are oft-expressed complaints such as these: "She doesn't give of herself," and "He's so cold, he never shows any feeling," etc.

Shaping techniques may strike some as too analytical and cal-

culating. The idea of initiating planned changes in another's behavior and actually keeping track of the progress in writing may at first glance appear offensive and dehumanizing. But in problem situations where these techniques could possibly bring about improvement, the choice seems to be the following: Either an individual can continue in his frustrated relationship with another person and express this frustration by negative feelings which may in turn serve to perpetuate or even increase the distress (9), or he can seek to use some techniques for bringing about a change, so that he will feel more positive and be able to maintain a more fruitful association. It was interesting to see the changes brought about in a mother who had come to us feeling completely frustrated, helpless, and exasperated with her child. Following the use of reinforcing techniques, she began to get some feeling of mastery over what happened and was able to realistically observe and record improvements in the child's behavior. The parent was then able to express more positive feelings to the child, who in turn responded by being more cooperative.

Let's use a detailed example to illustrate how shaping may be used. Consider once more the child (we'll call him Quid) who is very sloppy in his eating habits. The problem makes his parents uncomfortable and frustrated because they feel unable to cope with it. The child senses their helplessness and this in a way furthers his feelings of independence as well as his slightly defiant attitude. Although the parents' preoccupation with table manners may appear a bit trivial, it does exemplify certain patterns which probably permeate other aspects of this parent-child relationship. Let us see how reinforcement methods might bring about some improvements.

The parents must first define exactly what they consider "sloppy." They might list the following: (1) dropping bread crumbs on the floor and table, (2) chewing with mouth open and talking with mouth full, (3) spilling things on the table or floor, (4) getting greasy hands on the utensils which are used by others at the table, (5) using one's own utensils to obtain food from the serving dishes, (6) slumping, squirming, putting elbows on the table. The next step is to determine the frequency of these behaviors by casually jotting down how many times these offenses occur at dinner for a week. Suppose this list includes, 3, 4, 2, 3, 3, 4, and 3 offenses respectively for the seven days; thus, in our hypothetical case, Quid commits an average number of three offenses per dinner.

Knowing the average or habitual level of sloppiness per meal, we

next search for reinforcers which could possibly be used to influence that frequency—in this case, to increase neatness and thereby diminish sloppiness. In considering various things Quid likes, his parents might mention toys, favorite foods, permission to watch television at certain times of day, permission to stay up for half an hour longer than usual, a trip to a playground or zoo, going to the movies, or a larger allowance. They should select out of this series of reinforcements one which can be given, or about which Quid can be informed, right after a desired behavior occurs and which, furthermore, will not lose its attractiveness with repeated use. (Or alternately, as already suggested, several reinforcers may be selected for the same situation to prevent any one of them from losing its appeal.) The reward selected should be completely within the control of the parents, one that is not accessible to the child without them. A monetary reward might be a convenient reinforcer since it satisfies all these criteria.

Now, having selected a reinforcer and knowing that the average level of sloppiness is three offenses per meal, the parents can reinforce Quid with, for instance, a dime at any meal where he commits fewer than three offenses, and not reinforce him at all when his number of offenses is three or more. This schedule may be maintained for one or two weeks. If one day Quid drops bread crumbs on the tablecloth and chews with his mouth open but produces no other offenses he can be given one dime right after the meal and told, "This is for you because you've been tidy today." It would be expected that the frequency of Quid's sloppy behaviors will gradually diminish to an average of only two offenses per meal. The parents can then change their reinforcement pattern such that they reinforce Quid only for one or zero offenses, but not for two or more at any meal. When the habitual level of one offense per meal is attained, the parents can move on and reinforce him only when he exhibits no offenses at all.

Although in wording the preceding example we seem to have emphasized the *elimination* of untidy behaviors, it should be noted that in terms of what is actually communicated to Quid, either verbally or nonverbally, he is being reinforced and encouraged for the new, tidy behaviors which are replacing his untidiness. In other words, although change was expressed in terms of amount of untidiness, change was accomplished through positive reinforcement of more tidy behavior.

In considering any changes induced through shaping we need to

answer questions that may already have occurred to the reader: After the training period is over, and Ragent has obtained a desired change, and planned reinforcement stops—what happens? Does Prebyn revert back to his old ways? If so, what kind of shaping procedures minimize the possibility of a return to older habits and maximize the possibility that the new behavior will be retained?

The example in which Quid was trained for neatness at the table was taken from an actual case of behavior modification in which the child's sloppy habits in general, including his habits at the table, were mentioned by the parents as one of their less severe problems with the child. Being one of the simplest problems, sloppiness at the table was the first behavior we sought to influence with the parents' help. Considerable success was achieved as far as the parents were concerned in that within a period of three weeks Quid was behaving quite satisfactorily at the table. At that point we turned to some of the other problems that had been mentioned by the parents. We suggested a gradual elimination of monetary reward and the substitution of verbal praise or encouragement. Further, with time, *all* deliberate reinforcement was to be faded out with a shift from a continuous to variable ratio reinforcement schedule, which involved less and less reinforcement.

Two interesting changes occurred during this period when reinforcement and schedules were being modified. First, having mastered this one simple problem with their child, the parents began to express generally more positive feelings toward him. This change in their attitude was noted both in what they told us and in some of their spontaneous decisions about how to handle their child. For example, these parents were reasonably well off, but had seldom eaten out because of the embarrassment they felt over their child's messiness. One of their new decisions was to begin to eat out more frequently, something that was not only enjoyable for them but also considerably reinforcing for Quid. The second change occurred in the father who suddenly seemed to have more time to spend with his son.

Success in dealing with this unruly boy served to reinforce the parents' constructive behaviors vis-a-vis the child. As a consequence, we found that in tackling some of the later problems, the parents were frequently more resourceful in choosing reinforcers for their child, and Quid was more cooperative in his efforts to change his behavior. In some instances of subsequent shaping, Quid's parents

even told him what he could expect for certain changes in his behavior. He could then count on certain rewards, and proved himself quite cooperative in terms of the rapid progress he made.

Incidentally, some of the beneficial effects observed informally in this case were substantiated in one of our recent experiments which showed that children whose parents could communicate more positive feelings were less maladjusted than those whose parents tended to communicate more negative feelings (9). This could be because the parents of less maladjusted children are more willing to reward positive accomplishments.

We discussed Quid's example in considerable detail in order to emphasize the importance of the postshaping stages. The positive effects of shaping may be lost if attention is not given to these later stages. As we discussed above, behaviors shaped with positive reinforcers take longer to return to their preshaping frequency than do the same behaviors shaped with negative reinforcers. One implication of this is that a positively reinforced behavior is then likely to be repeated long enough to be inadvertently reinforced from the subject's environment, and thereby further perpetuated. Actually, as noted in Quid's case, such subsequent reinforcement is not so inadvertent after all. The use of positive reinforcers tends to create a more harmonious relationship and makes it easier for others in the environment to generally be more positively reinforcing.

Such positive feeling would have been absent if negative reinforcers were used. Imagine Quid's being punished consistently for his sloppy table manners; the undesirable behaviors would no doubt have ceased, but Quid and his parents would have built a wall of fear, resentment and negativism, a wall that certainly would have interfered with success and cooperation in all other problem areas. If one punishes without offering an alternative behavior that could be positively reinforcing, the person who is punished is likely to return to his old ways as soon as punishment ceases.

Since use of a variable ratio reinforcement schedule induces the most long lasting changes, it is best to use this schedule from the beginning if possible, or at least to institute it at an intermediate stage. This is because a variable ratio schedule provides a more harmonious, that is a less discontinuous, transition into the everyday situations where planned reinforcements are absent. Reinforcement may accidentally occur in such everyday situations and thus be consistent with the subject's expectations on the variable ratio basis, but

if he has been led to expect continuous reinforcement, he is sure to be disappointed and may then cease to perform.

To illustrate, Muffy is a child whose behaviors are first shaped for greater productivity in her school classroom with a variable ratio schedule. When shaping is terminated, her parents, as well as her teacher, may socially reinforce Muffy's new skills by showing their pleasure over her progress with her schoolwork. But even more interestingly, there are many subtle rewards that may follow from Muffy's better school performance, such as (1) implied superiority among her peers, a very powerful reinforcer which, incidentally, is maintained as long as one continues to excel; (2) the parents' willingness to buy her interesting and intellectually challenging gifts, partially due to their increased evaluation of her as a competent and intelligent child; and (3) a possible tendency on the part of the parents and teacher to treat her more like a responsible adult rather than an irresponsible child, another powerful reinforcer in our culture.

Muffy's example helps to illustrate that part of the challenge in using reinforcement techniques is for a parent, teacher, or psychotherapist to select a direction for change that will be self-reinforced when the program ceases—that is, to shape behaviors which will continue to be reinforcing for an individual. The difference between an ingenious teacher or parent and an average one is not so much the latter's inability to select behaviors that might continue to be reinforcing and therefore be maintained, but rather the former's acuteness in perceiving and shaping those behaviors which have more than the average likelihood of being positively reinforced.

Incidentally, in some unfortunate instances a misguided or unaware parent might positively reinforce and shape socially unacceptable behaviors in his child. This is indeed a partial basis for the development of psychopathology. Fortunately such cases are the exception rather than the rule, since most members of a culture have consensually shared or reasonably realistic ideas about what behaviors are positively or negatively reinforcing in any given situation. Section 3 of this chapter will discuss these ideas in greater detail.

The following illustrations will provide additional opportunities to study the selection of reinforcers in shaping.

*One of my classmates who does very well academically is*

constantly trying to impress everybody else that he knows it all. He is positive that he is always right and that anyone who differs with him is wrong. He shows a discourteous impatience with anyone who has trouble understanding the course material.

A person I know is a rich kid who travels quite a bit, and he never lets us forget it. For two or three months after a trip to New York, he brought out pictures and other such things to show about his trip. I used to try to change the subject but he would always return to it. This is one person whose behavior I have tried to change, but it just doesn't work with him; he keeps up his bragging.

Both of these situations are common examples of a person who has an area of recognition on which he relies too heavily to attain his interpersonal reinforcements. That is, both people have been encouraged and in some way reinforced in the past for a specific accomplishment, and now they have come to rely predominantly upon this single area; in doing so they have become objectionable to others.

How can such a situation be changed? It would be helpful for those who must deal with such a person to think of other attributes or abilities he possesses which could also be sources of gratification to him and to others. Behaviors in these areas can be positively reinforced while behaviors in the objectionable area are not reinforced either positively or negatively.

What might serve as suitable reinforcers? One can encourage him to elaborate when he begins to talk about some new topic, be more attentive to him when he does so, and even indicate explicit appreciation or acknowledgement. If he can gradually be helped to recognize that he has other qualities that his friends find worthwhile, he may begin to exhibit a more differentiated and complex set of interpersonal behaviors. This will serve to make him more interesting in social relationships and induce a greater sense of self-confidence.

Here is another situation in which shaping techniques can be applied effectively:

I know a person who seems to play games with me. He will refer to an experience—but only half of it. Then, when out of curiosity I ask him to continue, he answers tauntingly,

*"Wouldn't you like to know?" or "I'll tell you some other*
*time." Although this may seem like teasing, it irritates me*
*after awhile. I get the feeling of being shut out.*

First we may inquire why it is that such taunting occurs. There
could be several answers. When Prebyn does not finish a story,
Ragent's requests that he continue may constitute positive reinforcers,
since they indicate that his story was very desirable; also Prebyn
may enjoy the special attention exhibited by the listener, who
expects him to continue; or he may enjoy the feeling of having
someone "at his mercy," of holding the more powerful position
in the relationship. On the other hand, Prebyn may feel that his
story isn't that interesting after all and not worth completing—he
may be anticipating negative reinforcers or simply the absence of
reinforcers, were he to complete his story. We can thus account
for his behavior in terms of either (1) greater frequency of positive
reinforcers for incomplete narratives, or (2) anticipation of absence
of positive reinforcers or presence of negative reinforcers for com-
pleted narratives.

Assuming these alternatives, we can proceed to shape the behavior
as follows: (1) narratives that are completed, or come close to being
completed, would be positively reinforced; (2) no negative rein-
forcers (such as an expression of disappointment that the story wasn't
very interesting after all) would follow any completed narrative. The
specifics of the shaping schedule would of course depend upon the
frequency with which Prebyn typically finishes or nearly finishes his
narrative. Behaviors in response to an incomplete narrative would be
neutral—Ragent would pass it by, perhaps changing the subject, as
though nothing unusual had happened. These shaping procedures
will communicate to Prebyn that his stories can be appreciated when
they are completed and will also minimize the possible positive
reinforcers he derives from teasing. Therefore it is expected that a
reduction in the frequency of incomplete stories would eventually
result.

All the examples so far have involved situations in which someone
else's behavior required modification. We don't mean to leave the
erroneous impression that most interpersonal problems should be
viewed as "the other guy's fault," however, so we should note here
that sometimes it is far more economical and realistic to seek
appropriate changes in one's own behavior. Very often such is the

case when, for example, to overcome a certain problem would involve changing the behaviors of *many* others. The following may be such a situation.

*Cadenz: I am a fairly good singer, but because I do not wish to compete with others (match abilities), many people who know that I sing do not think I have as much ability as I really do. Although I enjoy athletic contests, I do not like to compete musically because the decisions of judges are very subjective. As a result, my true abilities are often underrated.*

Cadenz is concerned with influencing not just one but those many people whom he feels underrate his abilities. Instead of attempting to change many others he might re-evaluate his ideas about his own abilities or do something about expressing himself more effectively so that his abilities could be appreciated. For instance, if he is actually a good singer but lacks the skills to get the kind of social recognition he desires, some of the concepts of modeling which we will consider later on might be of some value.

The following is another kind of problem that illustrates the need for changing one's own behavior.

*Uriah: At some social functions I am appalled at the shallow-ness of people who subject themselves and others to an endless succession of trivial comments and hypocritical good wishes. At these times I feel degraded and alienated, although I have a certain sympathy for such empty people. A powerful urge to leave the surroundings overcomes me at these times.*

Uriah's dilemma lies in his own particular reaction to everyday social situations. Like it or not, he can probably do little about changing such behavior in the people around him. Instead he might (1) try to be more discriminating in selecting the people with whom he spends his time, or (2) examine his own behaviors to see if he himself in any way contributes to the superficial and unproductive quality of conversations. Rather than withdrawing from a group in disgust, he might try to take the lead in initiating more sincere and constructive topics for conversation. Such changes on his part would thereby make social conversation more reinforcing for him.

There are countless instances of lesser interpersonal problems in which a person might effectively use shaping techniques to modify

his own behavior. For instance, he might find reinforcement useful in improving his own study habits or trying to quit smoking (32). To shape his work or study skills, he could select reinforcers—food, recreation, listening to music—and decide upon a schedule of reinforcement that would be contingent upon his productivity. One may decide that if he can keep up two or more hours of work he is entitled to a particular recreation, and then reward himself if he succeeds. A good rule is to always select small meaningful positive reinforcers, which are very concrete and well-defined and which, again, will not lose their effectiveness with repeated use. In shaping a behavior that requires a great deal of effort, the best positive reinforcer would be one that also involves some relaxation, since relaxation in itself can be a positive reinforcer.

Shaping can also be used with considerable success to socialize animals or train pets. For example, one lady complained that she couldn't seem to housebreak her cat completely. He would sometimes use his litter box but just as often go in various parts of the house. She said that she had been patting the cat whenever he went in the litter box, but this had not worked. It was suggested that she think of some food which her cat was particularly fond of, and even keep him slightly hungry so as to make this food especially tempting. Since in this case the cat did produce the desired behavior, but not consistently enough, it was suggested that he be given a small amount of the favored food immediately after using his litter box. The timing of this reinforcement would of course depend on the frequency with which the cat went into his litter box; if it happened approximately twice a day, then he could be reinforced only that often. However, if visits to the box were very infrequent, the shaping could initially focus on behaviors of approaching the box, with the cat being reinforced for moving very close to the box, next for touching it from the outside, then perhaps for just spending some time in the box, and finally, only for actually using it.

As a final example for this section we will consider a situation which illustrates that reinforcement theory can be useful not only in overcoming existing problems, but also in determining courses of action for the future to maximize the effectiveness and productivity of the persons involved.

Suppose two men establish a partnership. One of them, Mr. Meadows, has considerable experience in the business they're starting, while the other, Mr. Greenfield, is in truth "green." Right at the

beginning, Mr. Meadows has a choice of several approaches. He could promise Greenfield all the possible benefits he might expect, or he could partially withhold such information. Making extensive promises at the initial stage gives Greenfield a very large reinforcer before he has done anything to help accomplish the goals. In contrast, if promises of benefits were to be made contingent upon Greenfield's contributions to the project, they would serve as reinforcers to encourage effort on his part. In sum, wholesale prediction of the positive outcome of an enterprise is less constructive since it is not contingent on the partner's contributions. Moreover, an all-encompassing initial promise detracts from the effect of positive benefits when they do happen, since they have already been taken for granted.

## INADVERTENT REINFORCEMENT OF
## UNDESIRABLE BEHAVIOR

Frequently certain behaviors are maintained because they are being reinforced in a very subtle way. In some instances Ragent may employ split reinforcers: a negative verbal (explicit) communication about a behavior along with a positive nonverbal (implicit) communication about the same behavior which is strong enough to counteract the effect of the negative verbal comment. We have all used such split reinforcers: When a husband surprises his wife with a fur coat on her birthday, she may respond with, "You shouldn't have done that, we can't afford it," while the pleasure in her eyes is obvious; and parents often have trouble refraining from laughter while reprimanding a child because what he did was cute even if it was naughty. Experimental findings have shown that in such instances, the facial expression or the intonation of speech tends to override what is said, so that the overall reinforcing quality of the message is positive (43). Even in cases where the explicit and implicit reinforcements are given at different times, the negative reinforcements may be overridden by more frequent nonverbal communications of pleasure, amusement or encouragement.

Although the inadvertent use of split reinforcers can be harmless (note the coy reaction to the fur coat) or even beneficial, there are times when its subtle quality can give it an insidious and damaging effect. The situations described on the following pages illustrate such cases.

### Parental Conflicts Vented on Children

Mr. and Mrs. Vine are in conflict with one another but do not dare, or are unable, to express their conflict or disagreements directly. Thus, while peace and good feelings appear to reign between them, either of them may use one or more of their children to vent a sense of frustration and aggression. Let's say that Vinette, one of the children, has a habit of being careless and breaking things and that this is particularly disturbing to Mrs. Vine. Mr. Vine explicitly discourages that behavior, by means of negative reinforcement, when it occurs in his wife's presence. But sometimes, simultaneously or soon afterward, he implicitly encourages Vinette by, for example, being amused by what she does. The nonverbal communication is subtle enough not to be detected by Mrs. Vine, but even if it were Mr. Vine could always deny the implication by reminding his wife of the explicit statement with which he chastised Vinette for her behavior. For instance, Mr. Vine might say angrily, "How many times have I told you not to get your mother upset in that way?" followed a few minutes later by, "Why don't we go out and take a walk while your mother is cooling off?" Vinette's apparently undesirable behavior is reinforced, since making her mother angry results in increased attention from her father. The positive reinforcement from her father outweighs the negative reinforcement of the chastisement. Thus, Vinette's undesirable behavior is shaped and maintained by Mr. Vine, to the distress of Mrs. Vine. Through this devious means of expressing hostility to his wife, Mr. Vine may be reinforcing a self-destructive or socially undesirable behavior in Vinette, since he may see the immediate effect on his wife but fail to see the long-range effects on his child.

This type of problem has been informally observed by persons working in family therapy situations and is one of the bases for the development of some severe kinds of psychopathology in children. The child in such cases is caught within a conflict and over many years is led to learn a series of undesirable behaviors which serve no realistic function for him but merely are vehicles for the expression of negative and hostile feelings between his parents.

### Frustrated Romance Situations

*Jill: A very close male friend of mine persists in doing terribly nice things for me, such as buying gifts and taking me to expen-*

*sive places. I have tried in numerous ways to discourage this behavior because I'm planning to get married to someone else, yet he still persists. I have tried everything—I have come right out and told him about my future plans, ignored him completely, and talked constantly about my fiancé in his presence, but nothing seems to sink in. I hate to be rude to him, and at times I find myself pitying him, which is the last thing I want to do. I am completely at a loss.*

Assuming that the man in question is not seriously disturbed, a likely way to account for this pattern is as follows. Jill implicitly communicates encouragement toward her suitor and his advances while she explicitly and verbally discourages him. Apparently she implicitly communicates that she enjoys his pursuit often enough for him to persist in trying, hoping that he can overcome the obstacles involved. But why does she nonverbally reinforce his actions? Was her statement above really insincere? Probably not. Probably it is a case of inadvertent positive reinforcement. Jill may do it partially because the perpetuation of this relationship is positively reinforcing for *her*, in that it is a constant reminder that someone holds her in high regard. By neglecting to mention the nonverbal communications which she gives him (and may be actually unaware of), her behavior in the situation seems perfectly rational, and his irrational.

Such a pattern is actually a typical one which in earlier days was analyzed in terms of the unconscious. A psychoanalyst might have said that Jill unconsciously desired to perpetuate her relationship with this man, that she had mixed feelings of approach and avoidance toward a "forbidden" male—an Oedipal conflict. Reinforcement theory, however, does not rely on past conflicts. It is based simply on the here-and-now information contained in the interaction between the two individuals. Perpetuation of a maladaptive pattern is viewed in terms of the reinforcing qualities of the messages. Below is a similar situation.

*Jack: A girl whom I consider to be merely a good friend considers me to be a potential husband. She is not sure she loves me, but I'm sure she does. She acts very possessive, always wanting to know what I've done, where I'm going, and what I want to be. She tries very hard to make into a love affair what I want to be only a good friendship. I do my best to indicate my disinterest in going the love route, but she persists. Some-*

*times I act very cold toward her and not once over a two year period have I ever called her. She gets hurt, of course, and says, "If that's the way you want it, fine." Yet she keeps on calling me, asking to go places with me, and acting in her love-possessed way. Again, nothing I do or don't do has changed matters.*

As in the case of Jill above, Jack may be perpetuating the girl's persistent efforts at establishing an intimate and lasting relationship by occasional nonverbal encouragement. It will be recalled that a variable ratio reinforcement schedule is the most effective, and it is likely that this schedule has been unwittingly used by both Jack and Jill.

Here is a third example indicating even more clearly how one party in a problem pair comes to expect certain behaviors. Amy refers to these behaviors in the second from last sentence of her report and is probably basing her inference on some of the nonverbal and subtle ways in which her boyfriend shows displeasure when she is not being possessive.

*Amy: The problem situation results from possessiveness between my boyfriend and me. There are times, for example, when he wants to go drinking with the guys. This in itself is fine, but if I haven't seen him in quite awhile, or have something special I would like to do with him at the same time, I get rather upset. If I try to pretend I don't mind, he can see through it. If I really don't care, he acts as if he expects me to be mad, and I start wondering why I'm not. I guess the problem is that I am pretty possessive, more so than he is.*

Amy's possessiveness is more a positive reinforcement for her boyfriend (i.e., making him feel important and needed) than a negative one (i.e., giving him a cramped or restricted feeling). Thus, he continues to expect her to act displeased and upset when he wants to do something which doesn't involve her. Faced with this expectation, she finds herself in the awkward position of communicating possessiveness even when she doesn't really feel it. Her possessiveness is thus both negatively and positively reinforcing for her, as it is for him. One reason for the perpetuation of this problem may be that acting possessive is the primary way in which Amy communicates affection and love for her boyfriend. Thus, one avenue of change

might be for her to seek other ways to reinforce him positively. Consider the following communications: "I don't want you to go out because I love you," "I don't want you to go out," "I love you." The first is undesirable, whereas either of the latter two could be appropriate since they do not tie "love" to "restriction." She could learn, then, to separate her communications of affection from those of demand and restriction. If her communications of love and affection were frequent enough, he might no longer need or expect her to communicate possessiveness. Further, having been assured of her feelings in this way, he might be more willing to comply with her demanding or restricting requests when they do occur.

## Underachievement Situations

For some people, failure seems unbearably painful and is avoided at any cost. The following examples illustrate some maladaptive strategies that such persons use to avoid the negative reinforcements that accompany failure. The strategies are maladaptive since they also involve the avoidance of competitive or other learning situations where success may be associated with occasional failures (25).

*Geoffrey: I am uncomfortable with my tennis partner, the person I always play with. When I lose a game, he acts as if I have intentionally played to lose.*

In the absence of additional information, we can speculate as follows about how this pattern is maintained. Geoffrey, who seems to be deliberately losing games, may nonverbally communicate a carefree or careless attitude toward his playing, suggesting that he doesn't care whether he wins or loses. For example, the partner may say, "There you go again! You hardly tried at all, you were playing to lose!" In response, Geoffrey may show verbal disagreement ("No, really I wasn't,") but disqualify it nonverbally with a facial expression or intonation suggesting that his denial was only half-hearted. Such communications thereby maintain his partner's doubt about Geoffrey's intentions of playing to win.

Why would Geoffrey want to mislead his partner about his intentions toward the game? Because by doing so, in the eyes of his partner at least, he never *really* loses except by choice, and he can thus maintain an image of being the better player. Unfortunately, however, the repeated implicit communication of carelessness makes

it more difficult for Geoffrey actually to try very hard while playing. So his strategy is costly to him. This pattern of interaction may have come about quite accidentally, but once the partner had reinforced Geoffrey's seemingly careless behavior, it became more likely that the behavior would recur.

Here is perhaps a more typical situation which you can attempt to analyze on the same basis as Geoffrey's example.

*Windy: My high school track coach thought I could do well but didn't believe that I also wanted to do well. He was always disappointed, since according to him I wasn't working up to my potential.*

Basil, below, is an underachiever who uses a strategy somewhat different from that of Geoffrey and Windy. He tells others that he is a failure, so that when he fails there can be no legitimate disappointment on their part, and when he succeeds there can only be pleasant surprise. The disadvantage of this strategy is that in our culture an admitted "loser" can be a social drag and therefore an undesirable companion.

*A fellow I date, Basil, is a very dear person but is lacking in self-confidence to a degree I find irritating. It is not reasonable that he should feel inferior to other men, because in his field he is talented, does fine work, and is recognized. However, on a personal basis he acts as though he weren't worth the attention he is given. He tries to make it seem he is a loser. It's as if he wanted pity, but I don't think he does. He sets nonprofessional goals with the idea that he won't get them or that he is not worthy of getting them. I tried at first to build up his ego, but he responded (in effect, never verbally) by denying that he was good or worthwhile aside from professional standards. He doesn't have a strong self-concept and seems bent on keeping things that way. I am puzzled—why should he feel threatened by the possibility that he really is a competent, enjoyable, and valuable person?*

Basil's lack of self-confidence is probably a long-standing pattern which he has learned to use in dealing with others. An indication of the type of reinforcer that serves to perpetuate this pattern can be found in the sentence, "I tried at first to build up his ego . . ." which

implies positive reinforcements of such declarations as, "I'm a failure," from Basil. In addition, he has a foolproof method for avoiding the extreme anxiety which he might otherwise feel upon failing. If Basil expressed a more confident attitude, then he would have to face possible distress, pain, and frustration upon occasional failure. Instead, he has adapted to, and maintained, his "worthless" self-image (after long practice) because it serves to dull the impact of failure.

Geoffrey, Windy, and Basil all have a distorted view of failure and are unable to accept it as a normal part of growth and progress. For them failure is distressing enough to be almost unbearable. In that light their strategies are probably easier to understand.

Let us digress from split reinforcers to consider others who, unlike people who avoid failure at all costs, seem driven always to succeed. As soon as such a person, sometimes termed a *counterphobic*, senses a possible obstacle in any particular situation, he throws himself into it completely and continues to struggle for new skills, refusing to quit until he has mastered them. He asks questions about how to do things, reads pertinent material, and watches others who are successful in that area, modeling their behaviors. Alfred Adler's concept of the inferiority complex in a way referred to this counterphobic type of reaction. He suggested that some people who are inferior in a certain aspect of living, such as physical ability, have a driving urge to excel in just that particular area. As a result of their persistent struggle, they often distinguish themselves by their accomplishments. We have all seen examples of this—a blind person who becomes an accomplished pianist, another person who overcomes a physical handicap and goes on to become an outstanding athlete. Less extreme examples might include many everyday situations, such as someone who is deathly afraid of riding airplanes. Rather than travel exclusively on the ground, he forces himself to travel by air, reads about the physics of flying, talks to the flight crew, and learns about each jet model in order to overcome his inordinate fear.

The counterphobic reaction is not necessarily typical, any more so than a phobic one is typical. But we mention both to illustrate the whole range of reactions that people adopt to cope with threatening situations—all the way from phobic avoidance and isolation to wholehearted immersion.

People who, to one degree or another, try to avoid facing fearful situations are generally referred to as *low achievers;* those who

deliberately try to conquer fears or difficulties are the *high achievers.* One of the characteristics that distinguishes high from low achievers is their relative emphasis on success and failure. Failure is especially painful for the low achiever while success is especially rewarding for the high achiever. This difference explains why a high achiever is more willing to persevere at a problem that might involve failure while a low achiever becomes discouraged and quits.

How can we understand the development of these relatively stable high or low achieving tendencies in terms of learning theory? How does one learn to be more or less persistent in the face of possible failure? Such learning probably occurs during childhood or early adolescence. In a family where a child is frequently encouraged and rewarded for his efforts at a difficult task, persistence would come to be seen as worthwhile and rewarding. In another family the parents may have impossibly high expectations for their child. The parents withhold gratification or reward until the child reaches one of these major goals. He might initially keep trying and actually succeed in small stages, but in the absence of reinforcers to encourage his small successes, persistence is extinguished. In yet another family, expectations might be minimal. The parents indulge and overgratify their child in every respect, reinforcing him whenever the opportunity arises and irrespective of his activities. In this case the child would not have to work at or persist in developing skills in order to earn some of the rewards that most children have as they grow up (40). When he finally moves outside his family environment, he faces a considerable handicap since he discovers that rewards are no longer so readily available and that he greatly lacks the skills to obtain the positive reinforcements he once had. This new situation is equivalent to being faced with unrealistically high expectations from others, and so he learns to give up easily in the face of adversity.

Once such learning has occurred, either to achieve or not to achieve, we would next ask how it is maintained. Why does a high achiever remain a high achiever and a low achiever continue to function as a low achiever?

When a high achiever continues to persist in the face of failure, eventually he succeeds and therefore experiences positive reinforcement on a variable ratio schedule. Such reinforcement just serves to encourage him further, and his pattern of persistence is maintained in a stable way. A low achiever, in contrast, is caught in a vicious cycle. He avoids any situations that have led to failure and thereby

excludes for himself any possibility of being rewarded for persistence. Thus he is never reinforced for positive accomplishments following initial failure; avoiding the noxious situation which led to the failure does provide some measure of reinforcement through relief. In this way, any situation which bears a hint of failure becomes, through generalization, a negative one to be avoided, and his low achieving pattern is maintained.

The implication of this analysis is that the learning environment created for low achiever types should be different from that created for high achievers. The low achiever initially needs situations in which failure is very infrequent and where his efforts are often positively reinforced. He could gradually be exposed to more frequent failures as he attains mastery of a task. Learning should be presented to him not so much as a challenge but as an experience that is associated with cooperation and good feelings. It is not so critical for the high achiever to avoid the experience of failure. In fact, without a sufficient amount of failure he may even lose interest. He, therefore, should have a learning environment in which challenge and competition are basic factors and where success and failure occur equally. Once we can understand the mechanisms by which people cope with problems, we can devise reinforcing techniques that depend on the stable differences among the individuals involved.

### Suicidal Tendencies

Severe forms of problem behavior can be maintained when individuals in the immediate environment of a "sick" person unwittingly employ split reinforcers. Consider the following report:

*Anne: I am sick and tired of listening to my analyst and my school counselor tell me why I feel this way or that way. I have a desperate wish to die, but I'm scared to commit suicide. Besides, whenever I take any action in that direction I feel very guilty because my father has told me it would kill my mother, too.*

Although we haven't sufficient details to understand all the reasons for the perpetuation of Anne's condition, it is likely that one reason for her talk about suicide and dying is that she receives more attention, love, and concern when she verbalizes those things than at any other time. Perhaps this has been a long-established pattern for her

within her family—being reinforced with attention and concern only when she expresses some form of extreme helplessness and discomfort. When she expresses drastic ideas she suddenly becomes the focus of attention, and a number of people begin to fuss over her. Thus her talk about depression and suicide is reinforced and maintained.

The dilemma for the therapist in this case is that if he ignores the suicidal talk and tries to shape other more positive and constructive thoughts and behaviors in Anne, he runs the risk of actually endangering her life. If she feels rejected at the time she is most miserable, she may carry through with her threats. So to employ behavior modification techniques, the therapist would have to place Anne in a controlled environment, such as a hospital, to ensure her safety. Shaping techniques could then be devised to discourage her talk about suicide and depression and to reinforce positively those behaviors that are more realistic and adaptive.

### Psychosomatic Illness

Illness of any kind, physical or psychological, may come to be associated with positive reinforcements. Talk about being sick or even actual physical reactions can be shaped and maintained to a point where it is difficult to distinguish real illness from malingering (11). This may explain why escape through illness, either feigned or imagined, is becoming an increasing concern. Our assumption that physiological problems like headaches can be reinforced and modified is supported by experiments which show that physiological responses can be modified without even Prebyn's awareness that his reactions are being systematically changed (11, 14, 26).

Children or adults may be given undue attention, sympathy, privileges, and relief from responsibility when they are sick, which could encourage them to resort to any number of minor symptoms of distress—headaches, nausea, aches and pains. These psychologically-motivated illnesses serve as a means of escape from responsibilities and, further, as a source of gratification and attention. For example,

"Davey, your father wants the lawn mowed this afternoon before the company comes tonight."

"My stomach hurts, Mom. I just don't feel very good."

"Well dear, then why don't you go lie down and maybe your brother will do the lawn for you this time."

Another way to encourage the development of this pattern is for

a parent to let a child stay home from school because "he needs more sleep today," or "he didn't get his studying done." When the child sees that his parents don't mind such small, but still socially unacceptable evasions, he will be inclined to use that type of release more often.

## Riots

Social phenomena that we see more and more frequently are demonstrations, riots, and other kinds of aggressive group behaviors that are associated with reform on one hand and violence on the other. Riots may start for a variety of reasons, some of them completely unrelated to the social issues at stake—for instance, climactic conditions are known to influence unrest (it's worse on hot, muggy days).

We will not attempt here to evaluate these riots but rather to examine the techniques that are used in dealing with them. To understand this, the reinforcers have to be considered. Some of the positive reinforcers associated with rioting might include the publicity of news coverage of the causes being advanced and, in some cases, looting. On the other hand, negative public reaction to violence, physical injury, disruption of one's own community, and damage to property are all very powerful negative reinforcers associated with rioting. In short, riots are typically followed by a mixture of positive and negative reinforcers.

Several of these reinforcers are subject to the control of authorities. If a riot is immediately met with massive negative reinforcers—jail, injury, death, or in less severe cases expulsion from school—a temporary halt in the rioting behavior is obtained, just as would be expected following negative reinforcement of any behavior. However, as we have already discussed, there are other complex side effects of punishment, such as (1) aggressive retaliation to ward off further punishment, and (2) a kind of automatic reaction which is not necessarily directed at the punishing agent but is an undirected, random outward aggression. Thus, massive negative reinforcement increases hatred and aggression on the part of those punished and probably causes increased bitterness and disorganization in the community. A vicious cycle may develop, perpetuating more rioting, as has happened in some schools (Berkeley or San Francisco State), until rioting and aggressive social dissent become almost constant. In these situations, strong negative reinforcers alone will not eliminate rioting unless

force is used constantly, a solution that is not compatible with the American ideal.

Another alternative, again undesirable, is to meet the rioters' demands immediately after the riots. Such positive reinforcement would shape the behaviors of those who participate in the riots and thus perhaps make rioting an even more frequent means of voicing social demands. If such positive reinforcement happened only occasionally—if one out of every four riots received a lot of attention and the demands of the leaders were met to some degree—this would create a partial reinforcement schedule and would still be effective in maintaining and perpetuating the occurrence of rioting.

If we do not wish to maintain close surveillance of any and all individuals who might possibly incite a riot, and if we likewise do not want to create a society in which rioting is an everyday means of expressing social dissent, then we must not meet rioting behavior with immediate and exclusive positive or negative reinforcement. Positive reinforcers, especially, should be used neither to ward off a threat of riot nor just after one occurs. Positive reinforcers—the meeting of demands—should be employed, if possible, in such a way that those who are making the demands make no association between rioting, or the threat of rioting, and the positive reinforcers.

One important technique involves directing those who are instrumental in instigating riots into more constructive efforts, such as giving them some responsible position in an organization in the community. They then have the opportunity to use their leadership skills to deal with the problems facing a school or community where there is discontent. Ideally, such a technique could be used to counteract a community's problems long before they become full-blown and ripe for open violence. This may in part explain why riots don't recur in certain areas (such as Watts) where, although negative reinforcers were used initially in response to rioting, in the aftermath a number of programs were initiated in the community which positively reinforced constructive action.

This, incidentally, would be the same procedure used with any single subject who exhibits undesirable behaviors. Initially at least, it often seems that we are stuck with responding to the undesirable behavior *per se* right after it occurs, either by ignoring it or taking some form of positive or negative action. Our earlier analysis has suggested that, again, we should not wait until the undesirable behavior occurs in full-fledged form but rather we should begin to

shape in the desired direction other behaviors which occur inter-
mittently with the undesirable behavior. In this way the undesirable
behavior is extinguished (that is, not reinforced), while other desir-
able behaviors are positively reinforced. Anticipation of a riot,
however, is not always possible. We have previously discussed the
combined use of positive and negative reinforcers in response to
self-destructive or socially destructive behavior. Should a riot occur,
a similar technique might be used. That is, while punitive measures
are quickly taken to curb the destructive behavior, other information
can be gleaned about the rioters' demands and saved to consider
after the rioting has subsided. Thus, ideally, representatives of society
could deal with the relevant problems during those times when
unrest has not yet advanced to talk of possible riot. The representa-
tives could themselves initiate negotiation and other avenues of
discussion in which the problems could be brought up, discussed,
and possibly resolved.

## SPEEDING UP THE SHAPING PROCESS

One problem inherent to shaping techniques is that if we desire
to change certain behaviors which someone spontaneously emits,
then we must simply wait until he produces some action in the
direction of the desired change which can be reinforced. This makes
the application of shaping somewhat awkward since it can be very
time-consuming and erratic at the initial stages. Therefore, it is im-
portant to find eliciting procedures that will encourage variations
in the behaviors that are to be shaped. This section will include such
a series of techniques to speed up the shaping process particularly
during the initial stages.

### Verbal Requests for Change

One possible approach is simply to *ask* a person to change, indi-
cating the reward he can expect for his efforts. However, when such
a request is made, variability, either desirable or undesirable, is more
likely to occur. Thus, to return to Quid who had sloppy table man-
ners, his parents could have waited without comment until he ex-
hibited slight improvement and then gone on to shape the changes
as indicated; or they could have communicated to Quid that they
would like it if he were less messy. Let us imagine the alternatives.
If his reaction is to comply somewhat with their request, then he is

reinforced and shaping is initiated. But the child may well be initially defiant and produce even worse table manners than before. Such an increase is not cause for distress, however, because messiness would soon begin to return to its habitual level, and could thus be reinforced.

## Modeling and Prompting

In a new or ambiguous situation where a person does not know how to act, he often relies on others around him, imitating their behaviors. This imitation is known as *modeling* and it provides many additional opportunities to apply reinforcement techniques (5, 8).

A typical situation is the consistent reinforcement of undesirable but "cute" behaviors: "That scatterbrain smashed up her car again," followed by amused laughter; "Foxie bluffed through his book report today. I shouldn't have laughed along with the students but his antics were really very funny"; or parents who giggle with their children when one of them spills milk in a restaurant. Other people in the environment—classmates, brothers and sisters, or whatever—observe that supposedly undesirable behaviors were not punished when they happened but rather became the source of attention and merriment. This makes the social role or model which is implicitly and consistently communicated to the child not only one for him to emulate but also one which is positively reinforcing. Consider the following example of self-image and identity development.

Tang's parents see a strong resemblance between his features and those of Uncle Elvin. In the child's presence they mention this resemblance occasionally, and of course bringing up Elvin often leads to comments on his characteristics, anecdotes about some of the things he used to do, and so on. As Tang grows up, then, he is frequently reminded that he is like someone else and also receives information about that person. He perhaps gets an impression from the conversations he hears that Uncle Elvin was quite an outstanding figure (whether for good or bad) and begins to act like Uncle Elvin in some of the more obvious and easy ways to model. As the parents and relatives notice some of Tang's increased resemblances to Uncle Elvin, their ideas of their similarities are further strengthened, and discussed. Thus the cycle repeats itself. Through this process, Tang gains a detailed picture of a person's attributes and experiences, is reminded to behave like that person, and is reinforced for doing so. The reinforcement goes as follows:

When Tang acts in certain ways that resemble Uncle Elvin who was a rather significant figure for the relatives, he draws their attention and amusement—or possibly chagrin—becoming the center of attention. As he grows up he begins to take on more and more of Uncle Elvin's characteristics, a state of affairs that conforms to his parents' and relatives' expectations and provides him with a source of extra attention and reinforcement.

There are several important elements in the Tang-Uncle Elvin situation. First, when Tang lacks a repertoire of responses for a given situation, he is very susceptible to influence by models. The models may be other individuals whose behaviors Tang observes and emulates, or they may be roles which are verbalized by others as appropriate to that situation (or at least implicitly expected from Tang). In the examples we have considered, the circumstances are generally a question of what role to assume in life, that is, how to behave in various social settings. Naturally children have not established an identity as firmly as adults and are therefore more susceptible to any suggestions or guidelines that might be exemplified in others.

Second, persons in the environment of Prebyn somehow show an unusual preoccupation with either the model or the roles that they describe. That is to say, they talk about, attend to, or praise extensively either the models themselves or the roles associated with the models. This makes these particular models or roles salient aspects of the environment in which Prebyn functions. In the language of learning, these models are known as *discriminative stimuli*, because they are emphasized or set apart (discriminated) as special entities within rather complex situations—special because they signal reinforcement.

Third, any behavior of Prebyn's that resembles one of the model's tends to receive more emphasis from others than his other behaviors. In this way—through similarity with the behaviors of the model—a certain subset of Prebyn's behaviors is positively reinforced.

In short, the combination of a model (or a set of roles that correspond to a model) with reinforcement of any behaviors that emulate that model, can be an extremely powerful technique for shaping large sets of Prebyn's behaviors, particularly when he initially lacks a well-defined repertoire of behaviors.

The following experiment demonstrates the significant effect of using modeling to help children overcome their fear of dogs (7). One group of children who were afraid of dogs had eight "parties" to-

gether, during which they received prizes and candy and watched another child, the model, play fearlessly with a dog. A second group had the same series of parties with the dog present but without any model who played with him. The results showed that a significantly greater number of children from the first group overcame their fear of the dog. Also, in testing sessions one month later, more of the children from the first group were willing to be alone in a playpen with the dog.

Rosen used a form of modeling to cure psychotic behaviors. One of his patients denied any psychotic behavior, claiming his real trouble was a spinal malformation and an extra bone in his back, which gave him an odd, springing step (53). In the patient's presence, Rosen remarked off-handedly that he, too, had once had such a strange walking step, "when he was crazy." But when the patient tried to question him about his alleged symptom, he would talk of other things, ignoring the patient's wish to discuss the mutual problem. By pretending he was once psychotic and had experienced the patient's same symptoms, Rosen led his patient to see that the symptoms were gone and that Rosen was no longer crazy. The patient could thus view Rosen as a model—"If he got well, why shouldn't I, too?"

In using modeling, one must remember that people are more suggestible or malleable in unfamiliar circumstances. A model can then be a source of coping skills. Consider this application: If parents are attempting to teach a child a more regular set of working habits or a greater degree of persistence at solving problems, and if they have failed to elicit favorable behaviors in his habitual settings, they might temporarily make use of a new setting to encourage the new behaviors with modeling techniques. Thus, a vacation setting might provide parents an opportunity to set up a new kind of work-fun situation in which they exemplify ways to function that their child can copy or model. Any favorable response could then be reinforced and subsequently transferred (generalized) to their home environment.

While modeling refers to the process whereby elaborate sequences or complex sets of behaviors are imitated, *prompting* refers to the elicitation of one simple act. When we tell a child to "say dolly," we are using a prompt. If he says it we respond with "Good boy, good boy," and wait. If he spontaneously says the word again, we reinforce him; if not, then we prompt again. Most parents use the prompt

widely and intuitively with young children, accomplishing changes very quickly and subsequently reinforcing them positively.

Prompting or modeling can involve words or actions; nonverbal prompting techniques, as opposed to verbal ones, are usually more appropriate with adults than with children. It is easier and socially less awkward to prompt an adult with the use of nonverbal behaviors than to make an explicit request which may be denied, thus causing uncomfortable feelings for both parties. Explicit verbal requests for change need be used only when nonverbal prompts are not effective at all in initiating some variation in Prebyn's behavior.

For the case given below you might try to outline some modeling and reinforcement procedures, similar to those reported in the experiment with the children who were afraid of dogs, which Susie could use to help her sister.

*Susie: I tried once or twice to convince my sister to be more sociable. As it is, she isolates herself from almost everyone and has forgotten how to smile. She needs quite a while to warm up to even one person at a time, and with more than one she's static. I told her how much happier she would be associating with people and how not doing so could damage her chances when she gets older. I suggested that she join some club at her high school to begin to socialize, or maybe go to a couple of dances. She agreed with me but repeatedly failed to do anything about it. Apparently she wanted a change but she expected to have it just happen to her. She said she thinks she'll grow out of it.*

There are certain situations in which the socially defined "complementarity" of roles among participants detracts from the usefulness of modeling as a means for inducing changes in Prebyn. The basic assumption underlying modeling is that Prebyn identifies with the person whose behavior he emulates and that such behavior is appropriate and reinforcing for him as well as the model. Now, if Prebyn and the model have complementary roles in a particular situation, imitation of the model's behaviors may not be appropriate for Prebyn. For example, students may automatically assume a rather passive role in relation to their teacher due to the "complementarity" of their roles as defined in most learning situations. Inducing students to model teachers' behaviors becomes difficult under those circumstances. But at times it is possible to restructure the social situation

of teacher-learner to imply a more egalitarian social setting and thereby induce the student to model. This is precisely what happens in graduate seminars, where students begin to model and take on the behaviors of their teachers rather than assume a complementary relationship to them.

Educators make extensive use of the eliciting techniques (verbal requests and modeling) but traditionally do not employ shaping. Thus, although teachers may use themselves as models by writing or saying things in a certain way, they may overlook small improvements in performance, which could be reinforced and shaped in a desired direction.

## Using a Third Party as a Model

So far we have discussed two sets of eliciting techniques: verbal suggestions or requests for change, and the use of prompts and models. A third technique is the indirect use, in Prebyn's presence, of a third person's behaviors as examples to be modeled. This is accomplished by specifically calling attention to those behaviors of the third person which are desired in Prebyn. You may have noticed this pattern with Tang and his Uncle Elvin. Although in that case the pattern occurred inadvertently, the method can, of course, be used deliberately. Suppose, for example, it is desired that Lyon, your son, practice his piano lessons more faithfully. His sister Dandi usually practices quite adequately without being told, so on those particular occasions when Lyon is present, Dandi can be reinforced with praise, or told, "Since you've been practicing so well, we'll get you the new sheet music you've been wanting." This technique draws Lyon's attention to the desired behavior and to the relationship between that way of behaving and a positive reinforcer. As a consequence, the likelihood that Lyon will practice more may increase.

You may have used this technique intuitively by pointing out to a friend some behavior of a third person, and saying something positive about it. In this way, without explicitly asking for a change, you drew attention to the desired behavior in a third person and also reinforced it. Implicitly at least, your friend received some communication about the desired behavior and witnessed some reinforcers which could occur consequent to that behavior. Of course praise and compliments are only one way to reinforce, and you might have chosen anything else which you knew your friend valued.

Following are some detailed illustrations of this same technique as it can be used at home or in school situations.

Sometimes a teacher who is burdened with a large class of un-motivated students may find himself attending only to those who are misbehaving in order to prevent their behavior from disrupting the rest of the class. One of the problems with orienting toward a misbehaving student is that attention from a teacher tends to be a positive reinforcer; chastising the student does not constitute a sufficiently negative reinforcer to offset the increased attention. One of the reasons that attending to a student reinforces him positively is that, in a way, it communicates to him that he has the power to control the teacher as well as the rest of the class. So if misbehaving wins him attention and positive reinforcement, he will tend to main-tain that same pattern in the classroom. This problem is so common that a number of techniques have recently been studied in an at-tempt to counteract it. One way is simply to ignore the misbehaving students while positively reinforcing those who are producing the required behaviors. Once again, according to the principles of shaping, the requirements for positive reinforcement would initially be set relatively low and then gradually increased as behavior im-proves. Initially the misbehaving students may become even more disruptive in trying even harder to elicit attention from the teacher, particularly if the teacher is one who previously attended to their misbehavior. However, if the teacher continues to ignore these dis-ruptive behaviors they will tend to become less frequent.

Consider two students, Thorne who is being somewhat disruptive, and Leif who is performing reasonably well. The teacher may either tell Thorne to be quiet and pay attention, or say instead, "I like what Leif is doing, class," thus attending to the student who is producing the desired behaviors. The second is the far superior choice. Of course the teacher would not always praise the same student—doing so would label poor Leif as a teacher's pet and alienate other students from him. The shaping would rather be directed toward all those students who are responding in some degree to the teacher's directives. Probably most students would receive a positive reinforcer over the course of a week. Meanwhile, the students who misbehaved and therefore were ignored would have been forced to seek new ways to obtain positive reinforcement.

It is easier for a teacher to initiate this technique with a new class than to change over to it in the middle of a school year. When from

the beginning a teacher ignores misdeeds and positively reinforces desired behavior, increases in disruptive behavior are not expected from those students who have shown such tendencies in the past; the teacher in a way has presented a new kind of image vis-a-vis the class, and students quickly adapt to that role. They begin to perceive the teacher as someone who seems oblivious to "goofing off" antics but who offers much attention and recognition for positive actions.

Of course, the above classroom technique can be translated directly to family situations. Some parents drift into the habit of attending to their children only when they are being naughty or unruly, which forces the children to misbehave in order to be noticed by the parents. Here again, the parents have a choice between negatively reinforcing the behavior of a difficult child or positively reinforcing the good behavior of another child in the presence of the disruptive one. Positive reinforcement is the superior method, not only because it does not encourage negative behaviors through undue attention, but also because it creates a more positive relationship between parents and children. As we have already seen, when a child perceives positive feelings he tends to reciprocate them, and when he receives them regularly he becomes even more manageable or more responsive to the parents' needs and desires.

### The Token Economy

The earliest and most successful applications of reinforcement theory have occurred in those social situations where Prebyn is socially subordinate to and/or dependent on Ragent, such as the relationships of children to parents and teachers (10), employees to employers, psychologically disturbed clients in a hospital to the hospital staff (1, 12), and criminals or wartime prisoners to their prison staff (29). Control over privileges is a basis for devising some very powerful reinforcers (10). Where the agents have almost complete control over at least the physical aspects of the environment, some dramatic changes in the behavior of large numbers of dependent individuals have been obtained. *Token economy*, so-called, is a reinforcement system that offers great versatility in many such settings (1).

The token economy makes it possible to reward desired behaviors immediately with a token, chip, or some other symbolic reinforcer. The system relies on two principles: (1) Making clear the relationship

between a reinforcer and a desired behavior can be more effective in behavior change than reinforcing without explanation. (2) Humans and even some primates, such as chimpanzees, can be reinforced repeatedly and quite conveniently with some neutral object so long as they recognize that symbolic tokens can eventually be used to get actual material rewards, such as food, candy, or recreational privileges.

Individuals who understand speech should be told that if they produce certain desired behaviors they will be rewarded with chips, which in turn can be redeemed at certain times to obtain a variety of material reinforcers or privileges. For those who cannot understand speech, of course the relationship between the behaviors to be reinforced and the tokens must remain implicit—that is, the first principle cannot be used. However, there is a technique for making the connection between symbolic and actual reinforcers. An animal subject or a retarded child, for instance, can be provided with tokens and placed in a situation with a model who can illustrate the value of the tokens. For example, the model may drop a token into a machine which gives him a candy bar or a toy, which he then enjoys in the presence of the child. At this point, if the child is provided with one or two tokens he is usually found to imitate the model.

Once the significant relationship between the token and the other reinforcers is established, a graduated schedule is used to develop the child's ability to delay use of the tokens for longer and longer periods. One technique might require a single token for a candy bar at first, then two, three, four, and finally five. Or, the room in which tokens are exchanged for reinforcers may be open only certain times during the day, and so forth. The animal subject or the child is thus taught to appreciate a symbolic reinforcer and continues to see it as a reinforcer even when he must wait to cash it in.

The use of such token economies in state hospital wards has frequently brought on dramatic changes in the wards' social environments. Nurses and other ward attendants are provided with the tokens and detailed lists of desired behaviors which are to be shaped among the patients. The patients in turn are made aware of the relationships between the tokens and various privileges and rewards that the tokens will "purchase." Whenever a patient in the ward produces a desired behavior, any nurse or attendant who observes it

can give an immediate and effective reinforcer. The desired behaviors may be a display of socially appropriate actions as opposed to "crazy" ones, a willingness to talk, cooperation with other patients in carrying out various duties on the ward, conversation which anticipates leaving the hospital and considers some of the realistic problems associated with life outside the hospital, etc. In this way, the behaviors of large numbers of persons are shaped to approximate those of people outside the hospital setting, and therefore provide a basis for a graduated transition of the patients to their home environments (1).

The methods of the token economy have obvious applications with children at home or in the classroom. Since there are numerous difficulties involved in using immediately available material reinforcers, an analogue of the token system can be used in which children collect points, consequent to certain of their behaviors, which apply toward subsequent reinforcement. In this way, the symbolic reinforcer can be used with much repetition and over several days. The delay period between the time a child receives the symbolic and the material reinforcers would of course depend on the level of his development; the interval would have to be much shorter for infants and children of two or three years than for a nine- or ten-year-old.

Kevin, a nine-year-old who was overweight was informed that he could collect a certain number of points for losing weight, or for any other behaviors which contributed to loss of weight. A certain number of points were worth a certain toy or recreation. Kevin's parents helped to devise a shaping schedule for reinforcing his eating smaller quantities, or certain kinds, of food. Also, when at regular weighings the boy was found to have lost one pound or more, he received a certain number of points. The biggest reinforcers were designed to come from actual loss of weight, but component behaviors which contributed to loss of weight were also shaped. Some of the material reinforcers selected were a toy airplane which he had wanted for a long time, visits to a park where he could fly his airplane, or permission to stay out an hour later than usual to play with a friend. As in other instances of change, Kevin's achieved weight loss was a continued source of positive reinforcement in and of itself since he was able to participate more in sports and was generally more popular at school.

## ADDITIONAL REINFORCEMENT TECHNIQUES— SATIATION, NEGATIVE PRACTICE, AND GROUP REINFORCEMENT

### Satiation

*Satiation* is used to diminish the value of a reinforcer. For example, even if eating is positively reinforcing, it ceases to be so after we are full (or satiated). The satiation method in most cases involves the repeated use of a positive reinforcer to such an extent that it becomes negative. Almost all of us, on some occasion in childhood, have taken undue advantage of the opportunity to indulge in a favorite food, say banana cream pie, with the result that even the mention of banana cream pie was repulsive for many months thereafter.

This technique can have applications for overcoming some undesirable recurrent behaviors, such as smoking. A smoker could be induced to smoke at a much higher rate than usual, until satiation occurs and the smoking begins to be negatively reinforcing. Then he can be required to continue smoking even longer at a relatively high rate until he can no longer tolerate it. This procedure may take several three- or four-hour sessions, and can be done in groups (31, 32). Given the presently available evidence, it is difficult to say what the long-range effects of this technique are on different kinds of smokers. It is possible that the technique is more effective with infrequent smokers, like those who smoke socially but not necessarily when they are under stress. In general, development of methods for stopping the smoking habit will probably have to start with a characterization of types of smokers and proceed from there to the development of different techniques to counteract the smoking habit of each type.

Unfortunately, although it has been used quite successfully in hospital settings with severely maladjusted persons, the satiation technique for inducing behavior change has not been explored with unhospitalized persons. For example, one hospital patient hoarded towels in her room and also carried many around at all times by wrapping them around her arms and torso. She was induced to give up her hoarding behavior through satiation (1). For several days nurses took towels to her room, handed them to her and left. The patient was initially delighted to receive the towels, but as their

number increased she began to get more and more upset, and finally demanded that they be removed from her room. When the number of towels in the room exceeded 600 she began to take them out herself. Here then, through satiation, the positive reinforcer, a towel, was made negative and a lasting change in the patient's behavior was obtained. Subsequent to this satiation session, she kept an average of only two towels in her room.

## Negative Practice

In another similar technique, *negative practice*, certain recurrent undesirable behaviors such as tics can be made even more negatively reinforcing so that they are ultimately discontinued (61). A person is asked to practice his "involuntary" tic in front of a mirror. Of course at first he may not be able to reproduce an exact copy of his tic, but with practice he is able to do so. The practice accomplishes two things. Being required to repeat one-hour practice sessions about twice a day requires effort and is therefore negatively reinforcing. Further, the practice, which is aimed at an exact repetition of the tic, brings a so-called involuntary behavior under voluntary control. The end result, then, is a voluntary behavior that is negatively reinforcing; therefore it is discontinued.

Chronic headaches which are not biologically determined can sometimes be brought under control in the same way. The person who suffers from headaches is advised to practice his headache for one hour every day. He is told to set aside a convenient time, find himself a place where he can remain undisturbed for that period, and try to make himself get the headache during the entire hour of practice. Typically, the result of such practice is that the person discovers what shoulder, neck, or facial muscles are becoming tense during the headache. In this way, once again, a seemingly involuntary reaction is brought under voluntary control.

## Group Reinforcement

A person who is in charge of a group can minimize his own involvement as the primary reinforcing agent and also his sole responsibility for the effectiveness and productivity of the interrelated activities of group members. A group reinforcement technique has been found quite effective in helping to "spread around" this re-

sponsibility for overseeing and reinforcing each person's work in the group. In contrast to reinforcement of each individual's behaviors, this technique makes reinforcement contingent upon the entire group's performance.

Teachers who have to deal with unmotivated groups of students frequently encounter serious disciplinary problems. Such students might be told that if they all stay reasonably quiet during class, they will be allowed five minutes of free time at the end of the period. Two aspects of this technique require consideration. First, the reinforcement, the five minutes of free time, is explicitly made contingent on good behavior during the rest of the class period. Second, and perhaps more interestingly, the reinforcement is also contingent on the coordinated efforts of the entire class. The advantage of this is that the resources of the group are used to exert social pressure. That is, if the reinforcement is worthwhile to the group, then the one or two troublesome members who jeopardize it may become the target of the group's disciplinary actions instead of requiring controls from the teacher. In this way the group's own reinforcers are used effectively to regulate each member's behavior.

More generally, when the behavior of a large number of people is to be influenced, it is very probable that some of these people will not respond to the selected positive reinforcers. If the cooperation of the entire group is necessary to perform a task and if one or two of the members get out of line, the whole function of the group will be disrupted. Therefore the group can be induced to exert control on those individuals who jeopardize the group's reinforcement, in order to safeguard group goals. The movie "The Dirty Dozen" illustrates this technique very clearly. Twelve criminals were promised freedom (a very positive reinforcer) for succeeding at a certain military task which required the cooperative efforts of the entire group. At various stages of their mission, group members positively reinforced each other's successes while negatively reinforcing others who were about to jeopardize the project. The intervention required from the officer in charge of the group was minimal.

In most situations, then, where several persons are involved in a project, a group reinforcer can be quite effective because it minimizes the authoritarian role of the group leader and generates more responsibilities among group members. The technique may be quite suitable in a family situation where several children are involved and

may also have some interesting applications in hospital wards. In addition, it can be useful in somewhat rigid or bureaucratic settings where the focus of the individual tends to become so limited to his own role that he fails to see his relationship to others in the same organization. Very large groups, where it becomes too difficult for group members themselves to influence each other's behavior, can be broken down into smaller units, each under the direction of a group leader who is in turn part of a "group leader unit." The performance of each of these units may then be maximized with the use of the above technique.

## SUMMARY

Change is seen to be a function of positive and negative reinforcers. For the most part, the kinds of change we have considered here are most amenable to the use of positive reinforcers. Further, the process of change is a gradual one, involving small steps in the desired direction rather than large and discontinuous jumps. Therefore, one first determines the desired result and then rewards behaviors which increasingly resemble this result. In other words, Prebyn is reinforced for his "good mistakes" rather than for perfect performance all in one shot.

Since social influence relies heavily on the use of reinforcers, the effectiveness of shaping and related methods of behavior modification are largely dependent upon Ragent's ability to find the appropriate rewards for Prebyn. In fact, the primary limitation of the techniques is the difficulty in finding reinforcers that fulfill two conditions: using them repeatedly (1) does not induce satiation, but continues to be rewarding to the person receiving them, and (2) does not deplete the resources of the one who is offering them. Satiation can be prevented by introducing a variety of reinforcers and shifting to variable ratio schedules as shaping proceeds, or by replacing material reinforcers with social ones.

Variable ratio schedules of reinforcement elicit a high rate of response from Prebyn and are the most resistant to extinction. They also permit the smoothest transition away from deliberate reinforcement, since they most resemble real-life situations. In considering change brought about in a controlled environment, one must also anticipate the likelihood that the new behaviors will persist even

when planned reinforcement stops. Learning a new skill that is re-inforced in many social situations will eventually make it unnecessary for the original teacher or guide to be present.

Not only can the principles of reinforcement help us bring about positive solutions to problems; often they can explain how certain problem behaviors began in the first place. Among these latter situations are a child's tantrums or a person's chronic underachievement. Finally, psychosomatic illness, suicidal talk, or other bizarre behavior can often be analyzed in terms of the inadvertent but occasional reinforcement of the problem behaviors.

In its initial stages, shaping can be speeded up in several ways. One can tell Prebyn what is required of him and how he will be reinforced for certain of his behaviors. Or one can use models whose behaviors are reinforced in Prebyn's presence. Token economies illustrate both of these and have been used successfully in hospitals and other settings that can be carefully controlled. Token economies also use symbolic reinforcers such as chips or points. Symbolic reinforcers are preferred over material ones because they can be delivered as soon as the desired behavior occurs. Moreover, they help to build one's capacity for delaying gratification, because the immediate but symbolic reinforcer must be "cashed in" later.

Another technique based on reinforcement principles is satiation: Prebyn is given so much of a reinforcer that he tires of it. This method is used to help Prebyn overcome his excessive desire for something which may ultimately be harmful (such as cigarettes). Negative practice is a method used effectively to counteract involuntary behaviors and states such as tics and headaches. A final method is group reinforcement, in which reinforcements to members of the group are contingent upon the total group's integrated performance. Not every member of the group need be individually supervised, and development of leadership within the group is encouraged. People work cooperatively rather than independently, and disruptive members are controlled from within, thus freeing the group leader from the role of punitive agent.

**FOUR**

# *MORE*
# *ABOUT*
# *REWARDS*

## SOCIAL REINFORCERS AND COMMUNICATION

It is logical, as we have seen, that the most successful application of reinforcement techniques has been in situations where Prebyn is clearly subordinate to and/or dependent on Ragent. But some of the more common and challenging social situations in which change would be desirable involve people of equal status—situations in which Ragent has almost no control of the material reinforcers available to others, where the repeated use of a particular reinforcer is either not possible or feasible, or where Prebyn has little need for whatever reinforcers Ragent can offer. Such equal relationships might be the case between business partners, workers in the same setting, or marriage partners. What might be an alternative to material

reinforcers in such situations? *Social reinforcers* are one answer.

There are two aspects to social reinforcement: (1) the communication of liking, and (2) the communication of respect. Naturally there are many explicit (verbal) ways to indicate liking. Similarly, one verbal way to confer different degrees of status is through form of address. One may refer to Charles French, M.D. as "Dr. French," "Charles," "Charley," "Frenchie," or "You there!" The constantly repeated verbal and obvious communications of liking and/or status may often be inappropriate, seem insincere, or even connote a manipulative intent which might be resented. For this reason, knowing how to indicate such attitudes nonverbally can be important. A proficient use of social reinforcers requires an adequate understanding of these more subtle approaches.

### Nonverbal Communication of Attitude

Although there are practically no limits to the scope of our verbal communication, our nonverbal communication is restricted largely to conveying messages of liking or not liking someone or something, power or status relative to someone else, and responsiveness or unresponsiveness. Of course, when we combine different levels of these three dimensions, we can communicate fairly specific feelings —anger, love, depression, disdain. Anger is a combination of dislike, a moderate degree of power, and a high degree of responsiveness. Depression, in turn, is a combination of very low responsiveness, a low level of power and lack of liking or disliking.

Since our nonverbal messages can convey all these feelings, they can strongly influence the feelings which we communicate with words. For instance, depending on the nonverbal indicators accompanying it, "That's really great!" could be an expression of anger, disappointment, enthusiasm, or sarcasm. Some of these "indicators" are facial expressions, tone of voice, posture, touching, head nodding and other gestures, rate of speech, and speech errors. Most of us recognize intuitively that some of these behaviors reveal people's feelings—we have all inferred how others feel about us by their facial expressions, the way they touch us, the tone of their voice. Other of these effects may be more subtle. For example, while talking with another, you may have intuitively felt his feelings toward you without knowing what led you to that conclusion—it may have been his posture.

It is especially difficult to determine the feelings or attitudes of others when they express more than one kind of feeling at once, by simultaneously combining inconsistent messages in different behaviors. Take a situation where someone smiles at you and says something negative in a cheerful tone of voice. How are you to interpret that?

Problems can also arise in relationships because an individual may communicate something different from, or in excess of, what he really wanted to communicate, thus creating misunderstandings. For example.

*Lucretia: Whenever I try to communicate to my husband about the way I view his personality, although I try not to seem critical, I end up putting him on the defensive. This happens especially at times when I'm trying to understand his view of himself and the way in which he projects his own personality to others.*

Perhaps Lucretia's facial expression, tone of voice, or posture expresses negative feelings or hostility to her husband, even though her words are not critical. Or, on occasions when she finds negative words necessary, perhaps she tries to soften their impact through tone of voice or certain expressions, but her husband misreads her subtle cues. In either case, difficulty probably comes about because the communication involves more than just words.

Let's take a more detailed look at different kinds of behaviors by which feelings and status can be expressed. First, of course, feelings can be expressed with words. We can tell somebody we like him, we admire him, or we don't think he is important. But even verbally there are more subtle ways to convey feelings. One way is through the *immediacy* of speech (63).

Immediacy is the closeness we imply by choice of words or by the order of certain words in our sentences. To illustrate: You know a certain couple, Mr. and Mrs. George Washington. If you typically refer to them as "George and Martha," then George is probably the more familiar, important, or preferred one of the pair, and the reverse is true if you usually say "Martha and George." If instead you call them simply "The Washingtons," probably one is not more significant to you than the other, or even more probably, you aren't on very familiar terms with them. Saying "the Washingtons" is more distant and formal than using first names.

Immediacy, or rather the lack of it, is also evident when one person has to tell another something unpleasant. The task may be so distasteful that he will prefer to do it by telephone or in a written note in order to avoid a face-to-face confrontation. An employer, for example, might choose to transmit his discontent with an employee through a third person rather than do it himself. And how many times, on the afternoon TV melodramas, has someone departed, leaving bad news in a note because he couldn't face saying it in person?

In all these cases immediacy can provide information about what or whom we prefer or are more familiar with, or how we feel about what we say. In addition, certain word choices, more than others, indicate a closeness of the speaker to what he is talking about, and greater degrees of closeness or immediacy indicate more positive feelings toward the referent. For example, when talking about a group of people, one might say, "*These* people need help," which indicates more immediacy than, "*Those* people need help," but still not as much as saying, "These people need *our* help." Or, one might say, "Sam and I *have been* having a conversation," which would be temporally less immediate than saying, "Sam and I are having a conversation." Subtle signs like these, which the communicator himself may be unaware of, indicate his proximity to or identity with what he is talking about.

Another subtle aspect of verbal communication is the length of a person's utterances (39). When people of different status are talking together, some interesting effects have been observed. For example, the average length of most people's utterances is about half a minute, and usually they vary only slightly from the average. But if the person of higher status in a pair (Hi) nods his head frequently, the lower status person (Lo) produces longer utterances than usual. Also, if Hi varies his typical speech pattern with longer or shorter utterances than usual, Lo will follow suit. And finally, frequent interruptions or lengthy silences on Hi's part can induce discomfort or distress in Lo.

A third part of speech is its *vocal* aspect—that is, the way in which we say the words, our voice quality, intonation, pauses, and rate of speaking. One way to study the vocal messages in speech is to use an electronic filter which blurs distinct words but retains such qualities as intonation, variations in stress, length of pauses, and speech rate. When a sample speech is filtered in this way, tone of voice alone is still enough to convey liking, responsiveness, or power and

status. It is therefore quite possible, as we shall see, for a person to say certain words, such as "That's all right," but convey the opposite feeling in his intonation. Thus, just as in the case of facial expressions, the vocal part of speech provides an independent means for the communication of feelings.

There is one final aspect of speech that can communicate feeling or status: speech errors, which generally indicate distress, discomfort, or anxiety (37). Such errors, or disruptions, may appear in the form of unnecessary repetition, stuttering, omission of parts of words, incomplete sentences, and incoherent sounds such as "um" or "duh." A high rate of these errors may be associated with fear, which in turn implies that others present are relatively powerful and disliked. When the communicator addresses someone of higher status and is being deceitful, once again fear may be reflected in his speech errors.

So then, besides facial expressions, gestures, or touching, which you probably think of most typically when you hear "nonverbal communication," there are these other concomitants of speech, such as immediacy, intonation, and disruptions, which also communicate feeling. All of these implicit forms of communication are distinguished from explicit verbal communication, or that part of a communication which would appear in a written transcription.

There are several implicit movements and gestures which can indicate liking, confidence, or higher status of the communicator. For example, rocking movements and hand gestures which indicate comfort and responsiveness to the listener would be expected to occur more often when a speaker feels confident. Frequent scratching probably indicates anxiety or uneasiness due to dislike of the communication situation. Changes of position during a conversation, as when a person turns slightly away from his addressee, may be a sign that he is getting tired of the situation, implying, "You'd better wind up what you're saying because I have to leave soon." Posture can reflect a person's relaxed or tense state and thereby communicate his liking of another and also the nature of possible status differences (42). Greater degrees of postural relaxation are associated with more asymmetry in the placement of arms or legs, more sideways lean while seated, and a more reclining position. Thus a seated person who is minimally relaxed would probably be sitting up straight with his arms perhaps crossed, legs symmetrical, and both feet resting flat on the floor. A moderately relaxed person might lean forward at about 20°, lean sideways about 10°, and cross one foot in front of

the other leg. An extremely relaxed person might recline back at an angle of about 30°, sideways about 20°, and have his legs crossed with one arm flung over the back of his chair.

In a standing position the guidelines are essentially the same. Thus, to communicate liking one would avoid both extreme asymmetrical or symmetrical postures. Further, arm "akimbo" (hand on hip) positions which tend to communicate dislike or lack of respect would be avoided.

When a person is talking to someone he likes, he is generally moderately relaxed. He is likely to be tense when talking to somone who is threatening to him, especially if both of them are men. Further, when tension is combined with closeness and more eye contact, it is especially threatening. Extreme relaxation usually occurs when a person is talking to someone whom he doesn't like and who is viewed as nonthreatening. A person is likely to be extremely relaxed when talking to someone of lower status than he and only moderately relaxed with someone of higher status; when people of equal status are talking, the degree of relaxation falls somewhere between modrate and extreme. Thus, one can partly communicate respect by being slightly less relaxed than feels natural in a particular situation.

The physical distance maintained while talking is also indicative of how people feel; the more they like each other, the closer they get and the more they orient toward each other (24, 42). People of equal status assume close but side by side (indirect orientation) positions, whereas a lower status person orients face to face (directly) toward a high status one but at a greater distance. Eye contact, just like direct orientation, increases with liking of the other person. Similarly, one looks more into the eyes of an important or high status person than a lower status one. These findings suggest that respect can be communicated with distance, direct orientation, and eye contact.

Another form of communication, not used quite so frequently in our culture as in the Middle East, the Mediterranean countries, or Latin America, is touching or affectionate striking. It too can imply various degrees of liking or status in relationships. There are some interesting cultural differences in touching and its significance. It occurs often between same-sexed pairs in the above-mentioned cultures and connotes intimacy and liking, but only rarely does it occur in public between adult opposite-sexed pairs. In contrast, in our own Western cultures, adult persons of the opposite sex are

more likely to touch each other in public than are same-sexed pairs. The absence of touching between adult opposite-sexed pairs in Middle Eastern cultures, for instance, is due to the strict taboos about overt expressions of sexuality by females. There seems to be a dichotomous classification of women in either the "mother and sister" or the "fallen woman" categories, so that if a woman expresses even the slightest degree of interest, by perhaps returning a look from a strange man or smiling at him, she connotes that she is a loose woman who is possibly sexually available to anyone. She may thus be approached by strangers. Unfortunately, girls from Europe or the United States who travel in the Middle East often tend inadvertently to connote sexual availability in such ways, thereby finding themselves in awkward situations. In contrast, touching between adult same-sexed pairs in northern Europe or North America seems far less frequent primarily because of an oversensitivity to, and social disapproval of, even the slightest connotation of homosexuality. Thus, touching is approved only in special situations: German fathers and grown sons will often kiss each other in greeting or farewell; football players frequently hug each other after a touchdown or interception; basketball players whack each other on the backside before a foul shot.

Now, with cultural variations in mind, let us return to the significance of touching when it does occur. When communicators are relaxed, touching connotes liking, intimacy, and an equal or lower status (such as younger age) of the person being touched. (You might visualize here a situation in which an older person affectionately pats the shoulder of a younger one.) When two people are tense, touching connotes very strong negative feelings of hostility. In general, the effects of touching are quite pronounced, such that if it occurs in a relaxed and affectionate context, the implied liking may supersede possible implications of negative feelings communicated in other behaviors, such as absence of eye contact.

In a discussion to follow, the various nonverbal behaviors will be weighted, each one being assigned a different value to express its importance in the total communication of liking. Touching is probably the most important of these.

At this point let's briefly recall and summarize all the implicit forms of communication that can indicate liking and, separately, those that communicate respect (42).

We can communicate a greater degree of liking, interest, or

warmth, to another person by assuming closer positions to him, touching him, looking into his eyes, leaning toward him, orienting toward him, and assuming moderately relaxed postures. A note of caution: *Overdoing* the attempt to communicate liking in these ways can possibly repulse the other person. For instance, if he is unfamiliar, too small a distance or too much eye contact may be offensive. Thus, the variations which one can use to communicate liking would need to be restricted to a range which feels reasonably comfortable and which does not cause tension and avoidance in the other person.

Other kinds of implicit behaviors of course include immediacy. For instance, while doing things with someone else, we frequently have the option of saying, "Let us . . ." or "We . . .," instead of "I" or "You." The former connote a close feeling, the latter separation. Other ways to communicate liking through speech activity are to avoid interruptions of another's speech and to use positive intonation. In one study where children were socially rewarded with words such as "good" and "correct" it was found that those from lower socioeconomic groups, in particular, learned very quickly when their behaviors were shaped by these words spoken with positive intonation, but that learning slowed considerably when the intonation was neutral (63).

Notice in the next example how sometimes an inadvertent communication of negative feelings can create and perpetuate problems that puzzle those involved.

*Sally: My brother and I seem to have a rather continuous communication problem. We are still living with our parents and we get along well together—the atmosphere is friendly and light most of the time. But sometimes there is a disagreement over some detail, such as deciding the place to go or what to do with the evening, and then our communication becomes irritating and unsatisfactory, although we don't openly disagree. My brother just does not hear, acknowledge, or remember when I disagree with him, and he is also apparently unaware of the growing hostility and anger that this sort of behavior produces in me. Furthermore, he reacts with anger or sulkiness, not necessarily about the actual conflict, but rather over some other issue, whatever excuse presents itself. Therefore, we frequently end up quarreling about his unwarranted hostility toward me and never come to grips with the actual problem.*

It is possible to speculate, despite the absence of relevant details in

the statement of this problem, about Sally's contribution to the difficulty. When she disagrees with her brother, perhaps he doesn't interpret her communications as disagreements. She may have difficulty in this area with others as well. It may be that she verbally communicates dissatisfaction but nonverbally disqualifies it by suggesting through her tone of voice or gestures that she is willing to go along with him. A second possibility is that Sally is unable to interpret her brother's messages of dissatisfaction, anger, or frustration. She says that her brother does not explicitly recognize their disagreements, but it could be that he communicates his distress through facial expressions or postural cues, rather than by what he actually says. If this is the case, and if Sally could pick up these cues and discuss them openly with her brother, they might resolve their disagreements earlier. As it is, because she thinks that he is completely oblivious to the disagreements, she gives up trying to talk about them. When their frustration finally breaks through in another area, she considers the quarrel which follows to be the result of unwarranted hostility.

The nonverbal communication of status or respect is probably less familiar to you than the communication of liking, but it too makes up an important class of social reinforcers. Experiments have shown that if, immediately after someone says something, we agree by saying, "uh-huh," or by nodding our heads, the frequency of that speech activity will increase, which indicates that it was being reinforced (33, 39). This is because agreeing with someone in a way implies respect for him, and if nonverbal agreement occurs over a series of interactions it tends to imply that he is of higher status, more knowledgeable and more competent.

The absence of interruptions and letting the other person set the pace for length of utterances are two ways to communicate respect, since they imply that one is letting the other person set the ground rules for the interaction. Any kind of nonverbal behavior which implies to others that they, rather than we, are determining the patterns for our interaction (such as allowing them to select seating patterns) communicates respect, and therefore such behaviors on our part are socially reinforcing for them. These principles can be applied in situations where the behavior of another is to be modified through social reinforcement and, just as important, in situations where the inadvertent communication of equal status to someone who is of a higher status would be detrimental to the interaction.

For example, an applicant for a job who nonverbally communicates an equal status to the interviewer may decrease his chances of being hired. Or there are times when an employee finds that he is having great difficulty with his employer, but he can't discover the reason. The answer may lie in the fact that in his nonverbal behavior the employee does not communicate the required acknowledgement of status difference to his employer.

A discussion of status differences is often awkward in democratic societies. We do not advocate an emphasis on status difference, but we want to call attention to it as a significant source of difficulties in the communication process. There are those people in our society for whom status is crucial—something they feel they have acquired through a great deal of effort and wish to have recognition for. In order to have harmonious relationships with such people, one must communicate the appropriate level of status difference to them, nonverbally as well as verbally. Of course, if doing so seems unnecessary or an undesirable compromise, then one must selectively interact only with those for whom status is not a critical concern. The point is that if one at least understands the possible source of a problem in this area, he has the choice of either adjusting his own behavior to the appropriate level or, if such a change is intolerable, leaving the situation.

Consider the following report.

*Surf: Even though I know it is wrong to judge people by their appearance, I seem to do it anyway. If a person is ugly or messy, I feel superior and act cold and snobby. Frequently when I want to be more friendly and to communicate a feeling of warmth, I feel that the other person thinks I'm cold and unfriendly anyway. I also feel that people are afraid to talk to me. So apparently I appear snobby and unfriendly whether I want to or not. A couple of people have told me that once they got to know me I was friendly and a lot of fun, but that when they had first met me they thought I was a snob. I know I must change these aspects of my personality or attitude. As it is, I'm so careful about what I say, how I dress, the gestures I make, etc., that I can't really be myself. How can I make myself more open to others?*

Perhaps Surf, in terms of his facial, postural, and vocal expression, is making people think either that they are of lower status than he or

that he doesn't like them. If he is indeed concerned about changing the kind of attitude he communicates to others, he would need to assess his own behaviors in light of the experimental findings about liking and status differences, determine what he actually communicates, and decide how he could communicate what he really wants to. In this way he could focus on those behaviors that need to be changed. Needless to say, this would not be an easy task. Nevertheless, having a definite grasp on his problem, he could begin by making the least difficult changes in his manner and proceed step by step to more difficult aspects.

### Inconsistent Communication of Liking

You may have noticed that the vocal components of what we say often carry more weight than the words that we use. If a person speaks to you of something which is neutral on the surface, but does so in a negative tone of voice, you are likely to feel that he doesn't like you, doesn't like what he is talking about, or is being sarcastic (45). Or, if his speech is interrupted with errors, stutterings, or the like, you may sense that he is very nervous or perhaps not being totally honest.

It has also been shown that the degree of liking communicated facially is approximately one and one-half times more important than that communicated vocally (43). Thus, if there is inconsistency between the facial and the vocal parts of a message, the facial expression typically dominates in determining the total effect of the messages. In general the degree of liking which is communicated by simultaneous facial, vocal, and verbal messages can be expressed like this (43):

$$Total\ liking = 7\%\ Verbal\ liking + 38\%\ Vocal\ liking + 55\%\ Facial\ liking$$

Thus, of the three, facial expression is the most significant indicator of liking, followed by the vocal component, and then by the verbal. With this in mind, let's try to answer the question we posed several pages back: How do you interpret the message when someone smiles at you and says something negative in a cheerful tone of voice? According to the formula above either the smile (facial) or the positive tone of voice (vocal) would be sufficient to counteract the

effect of the negative words (verbal); the total message will be perceived as communicating a moderate to high degree of liking.

In order to obtain an even more general statement of the relationships among various behaviors, we might speculate somewhat to include touching and postures in the preceding group. Listed in order of importance, the various behaviors might go something like this: touching, facial expressions, intonation (vocal), postures, and words (verbal), with the position of postures and intonation possibly being reversed.

It is clear, then, that the communication behaviors that accompany words can either convey an attitude the same as, or opposite from, the words. Further, the nonverbal behavior may complement the verbal information by conveying a message about something else. For instance, while a salesman praises his product to a potential client he may simultaneously and nonverbally express liking for the client. His facial expressions, words, and tone may all be positive, but about two different things. Such a salesman may feel that you are more likely to like his product if he likes you.

## SOCIAL REINFORCERS IN ACTION

*Thwart: I am sitting by the fountain and listening to this cat rap about the war. The time approaches 2:00 p.m. and I begin to wish he would shut up for a moment so that I could excuse myself, since I have an appointment at that time. But he simply continues his harangue, so my departure is awkward and abrupt.*

Chances are that, as the time of his appointment approached, Thwart still sat facing his companion and perhaps continued to nod as he had throughout the conversation. Not knowing what to do, he simply wished his companion would stop talking. He could have used some subtle nonverbal cues to communicate lack of attentiveness—he might have turned away slightly and looked away more often as the time to leave approached, assumed a neutral rather than positive facial expression, or exhibited a slightly tense posture by leaning forward. All such behaviors would have been slight negative social reinforcers, and if Thwart had used them his companion probably would have sensed the difference and stopped to inquire, thus making his departure far less awkward. In such single-episode in-

teractions the use of shaping is not possible, so negative social reinforcers are used not to produce a lasting change in another's behavior, but simply to indicate disinterest or displeasure without resorting to explicit words which could embarrass the individuals involved.

In general, people intuitively and quite appropriately use some of the social reinforcers mentioned to communicate disinterest or the simple desire to terminate a conversation. Mutt and Jeff, who are conversing, both feel that it is time to stop, but due perhaps to the slight formality of the situation, neither one wants to be the first to bring it up. Mutt subtly communicates his desire to leave by moving forward in his chair and assuming a symmetrical posture; Jeff in turn "reads" this message and, realizing that the desire to stop is mutual, says something to terminate the conversation. At another time, Jeff might nonverbally express the desire to stop, surprising Mutt who had not thought of terminating the conversation. But then Mutt at least knows of Jeff's desire and can decide what to do next, with no one being offended by a too-abrupt verbal cutoff.

How might one use social reinforcers to resolve the following problems?

*Mrs. Baroom: My husband has a habit of speaking too loud. I generally have learned to ignore it, but it becomes especially embarrassing in quiet places where others are also present. I usually ask him to lower his voice and he does, but before long it's just as loud as ever again.*

*Cinderella: I have a roommate who always pretends to be quite helpless when it comes to work, such as washing dishes. She seems never to want to do what I want, only what she wants. When I make dinner, many times she picks at her food just like a baby and typically says that she doesn't like this and doesn't like that. She never offers to help, but very frequently complains.*

Although most people are responsive to social reinforcers, there are those who don't seem to respond to negative ones, who just can't seem to "pick up the hints." For them the perception of the meaning attached to some of these nonverbal behaviors has apparently been difficult, or due to variations in cultural or subcultural background,

they may interpret these differently. Such persons may thus frequently encounter explicit "rejection" or cause discomfort in others who cannot bring themselves to say something as direct as, "I have to go now," or, "It's getting very late, could you please leave?" Recurrent embarrassment in dealing with such persons could probably best be avoided by casually and indirectly mentioning the appropriate non-verbal signals at some other time.

## EXPLICIT AND IMPLICIT REINFORCERS

Most of the time in the shaping process we have a choice to make: Should we (1) explain to a person why, and with what, he is going to be reinforced, or (2) simply reinforce the desired behavior when it occurs without calling attention to the relationship between the reinforcer and that behavior? These alternatives have been explored experimentally in only a limited way, so it is difficult at this point to say which policy would be the more effective under which circumstances. As we mentioned above, some early experiments showed that when an interviewer nodded his head or said "uh-huh" in response to certain behaviors of an interviewee, those behaviors increased in frequency (33, 39). It thus appeared that change was occurring without the interviewee being aware that he was being positively reinforced for those particular behaviors. However, subsequent experimentation showed that the *speed* with which the interviewee's behavior changed was correlated with his awareness that the reinforcers he received were due to particular behaviors (46).

Such findings might lead us to suspect that, in general, it is more effective to inform Prebyn that he can expect to receive certain rewards for some of his behaviors. But such a conclusion would be premature, since (1) the situations in which the preceding findings were obtained usually involved a Prebyn who was dependent upon or subordinate to Ragent, and (2) the behavioral changes desired were simple enough that it was not very costly or distressing for Prebyn to produce, temporarily at least, what was being required. Consequently we cannot automatically generalize these experimental conclusions to situations in which Prebyn is reasonably independent of Ragent or when considerable effort is required of Prebyn.

In the absence of any further experimentation, then, the following general guidelines are to be considered tentative. They are based on the simple assumption that telling a person he will be rewarded for

producing certain behaviors should be at least as effective as telling
him nothing. The obvious and major exception would be with a
person for whom manipulation by another is intensely repugnant.
While most of us may be generally resistant to influence by another
person, the negative reinforcement which some experience, particu-
larly if it is a peer who wishes to influence them, may be too difficult
to surmount with any positive reinforcers that might be available.

Given the preceding assumption, our first suggestion might be to
define those social situations in which Prebyn would be least likely
to resist the idea of influence. In many social situations it is recog-
nized that certain members have the right to influence others and
that such influence need not be, and generally is not, resented: with
child-parent, student-teacher, patient-doctor, and employee-employer,
explicit reinforcers can probably be used more effectively than im-
plicit ones—often, indeed, they are expected.

In contrast, in situations where Prebyn and Ragent are peers and
where the socially defined roles do not make acceptable one person's
deliberate influence of others, then Prebyn's possible sensitivity to
manipulation should be carefully considered. An obvious example
would be someone who is resentful and antagonistic to authority
figures in general. If one were to tell him directly that he would
receive certain rewards for producing certain behaviors, he might
refuse to cooperate altogether. Or he might mock the procedure by
complying only to receive the reward, ceasing to produce the desired
behavior as soon as reinforcement stops. Such difficulties can be
avoided by first assessing Prebyn's sensitivity to manipulation and
using reinforcement which is not obvious.

### Inconsistent Reinforcement

We have already mentioned the situation in which one person
explicitly tells another not to do certain things but then implicitly
and positively reinforces the so-called undesirable behaviors when
they do occur. Further, our discussion of the nonverbal communica-
tion of liking suggested that when the nonverbal part of a message
is inconsistent with the verbal one, the nonverbal part dominates
the total implication of the combined message. We thus have the
classic "no" from the girl who is nonverbally communicating "yes"
to a suitor's advances, or the barely concealed amusement of the
parent who chastises a child for some naughty act.

Such inadvertent inconsistent reinforcement is one possible ex-

planation for the development and perpetuation of pathological or maladaptive behaviors. You may recall Anne, who had "a desperate wish to die" but couldn't bring herself to commit suicide. If we were to ask Anne's parents or psychiatrist what they think about her suicidal talk they would tell us that it is painful and distressing to them. But they nevertheless inadvertently reinforce it by their nonverbal attentiveness and expressions of concern to Anne when she begins to act "sick."

But are there, in contrast, any circumstances in which inconsistent reinforcement might serve some useful function? And might this inconsistent paradigm (negative verbal coupled with positive nonverbal) ever be more effective than positive verbal or nonverbal reinforcements alone?

Milton Erickson has obtained some rather dramatic successes with obstinate children which can justify the deliberate use of the inconsistent paradigm (23). In one case a mother complained that her son, Thumper, was completely beyond her control. When Thumper was brought to visit Dr. Erickson, he was asked to come and sit down, but the boy stomped his foot and said no. Dr. Erickson complimented him on his strength and ability to stomp his foot and asked him to do it again. Thumper did so and was complimented again, and then he was asked to stomp harder and harder. He obeyed and continued until he was exhausted and, coincidentally, quite cooperative with the doctor. In this situation, although Thumper was ostensibly being explicitly and positively reinforced for stomping his foot and refusing to take a seat (i.e., disobeying), he was implicitly being reinforced for obeying a demand of the therapist. The method can also be viewed as an application of the satiation technique.

Although Erickson did not analyze them in terms of reinforcement theory, his cases can be seen to illustrate the positive results of combining explicit reinforcers with more potent, and occasionally contradictory, implicit reinforcers.

Further, as already mentioned, when attempting to influence someone who habitually resists any authority, one should use implicit positive reinforcers in shaping. But here too the use of the inconsistent paradigm can minimize even further the possibility for Prebyn to make any logical connection between the reinforcements and the requested changes. If Ragent verbally and negatively reinforces certain of Prebyn's behaviors while nonverbally and positively reinforcing them at the same time, Prebyn will be confused about what

exactly it is that Ragent wishes. This confusion can work to Ragent's advantage by giving Prebyn the satisfying impression that his behaviors are actually contrary to Ragent's desires. Thus Prebyn will be concurring with the changes desired without realizing he has been influenced.

It can be suggested, then, that the deliberate use of inconsistent reinforcers could prove beneficial when it is desirable to camouflage Ragent's intentions. But they would generally be used only temporarily to counteract drastic circumstances of obstinacy or rebellion.

In this same context it is interesting to examine the typical psychoanalytic or Rogerian therapy, in which the therapist will usually make it clear to his patient that he doesn't intend to influence him (15, 20, 52). For instance, he will not give straightforward answers to questions from the patient, such as, "Doctor, what do you think I should do about this?" The doctor responds with, "Well, what do *you* think you should do about this?" After a few such sequences, the patient realizes that the therapist will under no conditions make suggestions about how to act; indeed, in most cases of therapy with only moderately disturbed persons, a therapist might actually succeed in never having to make a verbal request or suggestion. Nevertheless, therapists can and do, in quite subtle ways, differentially reinforce various behaviors of their patients, whether deliberately or not. Perhaps Freud realized this when he decided to sit behind the patient's couch, so as not to be visible to him. This tactic helped reduce a large number of cues from facial expression, posture, or movements which could communicate varying degrees of positive or negative feeling in response to what the patient said. But even then, such feelings could still show up in intonation, speech patterns, or different responses to various of the patient's comments, such as asking for clarification at one point but not another, saying "Um-hmm" only at certain times, and so on. Such minimal cues from the therapist are significant for the patient, particularly when the therapist is not in sight. So there still remained a possibility of systematic reinforcement of a patient's behavior.

Thus, even the most "neutral" psychotherapeutic situation offers ample room for inadvertent reinforcement of a patient's behaviors; indeed, if one observes such an interaction through a one-way mirror, the inadvertent communications of preference for certain behaviors of the patient are quite evident, particularly on the part of student therapists, but even in experienced ones. Some, of course,

make deliberate use of this implicit reinforcing technique; but even those who deny any attempts to guide their patients' behaviors do guide them inadvertently (59). For instance, during an initial interview, the therapist may show greater interest in the patient's bizarre ideas than in his everyday experiences. In fact, some standard psychodynamic testing procedures, such as Rorschach testing, place more emphasis on the questioning of a patient when there is any hint of a bizarre idea in what he says.

During later stages of therapy the focus shifts to more constructive behaviors. When a patient returns to a session and reports certain successes with his problems, the therapist may express, ever so slightly, a greater degree of interest. He may lean forward more, look more directly at the patient, or use his first name more often when addressing him. All these signals communicate a more positive feeling toward the patient. If, in contrast, the patient returns to a session with only failure to report, his therapist may not be so nonverbally positive.

It is important to recognize that in the typical psychoanalytic relationship, even the most minute social reinforcers assume a great reinforcing function, because the approach generally involves making the patient very dependent on the therapist. The therapist becomes a crucial figure in the patient's life, and the merest suggestions of approval or disapproval can be powerful reinforcers which, in the long run, have a considerable influence on the patient's behavior.

The effectiveness of a psychoanalytic or Rogerian therapist, therefore, can be attributed in some measure to his use of implicit reinforcers in a context which, explicitly at least, claims to wish not to openly influence the patient (59).

This explains why the rule of being "neutral" has been developed and maintained—it is a safe posture to assume. A neutral therapist who never explicitly advises his patient and only implicitly reinforces and shapes his patient's behaviors cannot be rebuffed or criticized or have his authority called into question. The patient has no grounds for accusing him with "I tried what you told me and it didn't work."

## THE RELATIVITY OF REINFORCERS

Positive reinforcement can significantly influence the course of development in any relationship. The degree to which we are positively reinforcing toward another person determines the extent to

which that person likes us, wishes to affiliate with us (13), or conforms to our expectations. More generally, our ability to be positively reinforcing in part determines the possibility of our initiating and maintaining relationships with others. In this section we will consider how the level of positive reinforcers can accidentally contribute to undesirable developments in various relationships.

There are several patterns which typify the exchange of reinforcers over the course of a relationship. One might begin with high positive reinforcement which gradually decreases as time goes on. Another might begin with only slight positive reinforcement which gradually increases with time. A third might involve a moderate and steady level of reinforcement, and a fourth might make reinforcement conditional upon desired behavior, as in shaping.

We must next consider how and if decisions about such patterns can be communicated. In most social, friend-to-friend situations, it is not typical for people to barter for one another's friendship by saying, "Well, I'll make a deal with you—I'll do *a, b,* and *c* for you if you in turn do *d, e,* and *f* that I like." But there are certain exceptions where such "deals" are explicitly made and socially acceptable. This is particularly so in professional situations where there are clear-cut status differences between the participants. An employer and employee decide right at the outset about what their reinforcing behaviors toward each other are to be. The employer reinforces with a salary; the employee reinforces with the work he performs. Also, subsequent to the bargaining, if there is any, the reinforcements from each party toward the other are supposedly constant—the pay is constant as are the responsibilities of the employee, and in the future an increase in the reinforcers from one party is generally anticipated by a proportionate increase in reinforcers from the other.

So then, in situations such as the one above, the outright verbal communication of the expected reinforcement levels between two parties is one possible avenue. However, more characteristically, the initial expectations of participants in a relationship are inferred and evolve as the individuals interact, observe each other's actions, and draw conclusions about how reinforcing they are for each other. If after meeting someone we decide we like him very much, it may indicate that he was highly reinforcing to us during that initial encounter. Incidentally, our own experimental findings have indeed shown that how much we like somebody else increases with his positive reinforcements to us and decreases with negative reinforce-

ments—but, interestingly, our reaction to someone is influenced more by his positively reinforcing quality than by his negatively reinforcing quality. If we like someone whom we've just met, it probably indicates that he has in some way been positively reinforcing to us (he showed concern for our problems, was considerate, or was a very happy and entertaining person). If we decide we dislike him, it is likely that he was not positively reinforcing and was negatively reinforcing (he insulted us right away, was rather loud, hostile, or stand-offish).

Let us consider a few problems which came about because an individual failed to recognize the full implications of entering a relationship with a certain level of reinforcers for others, and later on was unable to maintain that level satisfactorily. Note in the last sentence of Christine's statement how she defines her own role as contributing to her problem.

*Christine: I often have problems because of my inconsistency in using the word "no" in regard to doing favors for others. I am fairly generous with my belongings, such as my clothes, car, etc., but occasionally when I know I really can't afford the time, or don't want to loan my car, I often don't have the courage to say no. So I wind up begrudging the things I do for some people and inconveniencing others who depend on me. At times when I do say no, I find it difficult to say it tactfully. The person ends up thinking I am selfish, even though I may have done many things for him or her before. They seem to think, "You've done it before, why not now?"*

Christine's acquaintances have learned to expect high levels of positive reinforcement from her—a situation she cannot maintain without undue distress for herself. For instance, it is so accepted that she will loan her car that her occasional refusals are misunderstood. Those same people who misunderstand are probably neither surprised nor offended when refused by another, who hasn't made a practice of loaning his car in the past.

Why is it that an individual selects such an unrealistically high level, at least in terms of material belongings, of positive reinforcement toward others? If how much people like us is a function of how positively reinforcing we are toward them, then some persons who lack (or think they lack) other internal resources to be positively reinforcing may rely primarily on material gifts to supply positive

reinforcement to others. But such excessive reliance on material reinforcement may eventually become taxing.

It is also possible that one may have an excessive need for affiliation, so to get it he tries to be positively reinforcing to others in any possible way. Either way, he has implicitly decided to be highly positively reinforcing, no matter what, and consequently he occasionally finds that in order to maintain the level of expectation he has established for others, he himself must suffer. Once he has established such expectations, he dares not fall short of them since doing so might anger or upset his friends and jeopardize the relationships.

To change such a distressing pattern once it has been established presents quite a dilemma. Naturally one of the easier first steps could be to initiate new relationships in which high expectations of positive reinforcement are not given. When a more realistic pattern is established from the beginning, it is unlikely that refusals would bring threats of disruption to a relationship. This phenomenon can be understood in terms of Helson's adaptation level theory, which we shall discuss at length further on (27).

Initiating new relationships on this basis is still not an answer for alleviating the uncomfortable circumstances of the old ones, however. Christine, or anyone else who has such a problem, would of course not wish to abandon her already established relationships with friends and relatives. So to change such patterns gradually, Christine might think of a series of graded situations, first mastering the ability to say no in the least distressing ones, then gradually progressing to more difficult ones where a refusal might be concomitant with distress, either for herself or the others. New relationships could provide opportunities to rehearse the refusal of her help in the old ones. This would be an easy way to initiate the new habit, since consistently meeting requests for help is certainly not generally expected or normal in our society, particularly at the initial stages of a relationship. She could thus offer help at those times when she considers it appropriate, but would not be at the mercy of an already well-defined role in which she must constantly comply with requests for help.

Following is a problem similar to Christine's.

*Curtis: There are times when I feel I am being used, but every time I try to do something about it, it doesn't work out. For example, friends or relatives will ask me to help them with*

*something. After awhile I end up doing all of the work for them while they take it easy. But when I tell them I refuse to help any longer, I feel guilt, because I am afraid they may be hurt or angry with me so I end up helping them anyway.*

In part, Curtis probably seeks such roles because of the good feeling (positive reinforcement) he gets from being an indispensable friend and adviser. But playing such a role vis-a-vis friends and relatives becomes an excessive burden to him which he begins to resent. Since he has consistently assumed this role of responsibility when people have sought assistance, it is very difficult for him ever to refuse. When he does refuse, others feel hurt or even angry and resentful, which in turn makes him fearful of losing his friend and guilty for arbitrarily isolating a certain individual and refusing to help him.

In Curtis' case the goals might be (1) gradually to diminish his own level of reinforcement toward others to a level that allows him to live reasonably comfortably with others' demands on him, and (2) to do so without rejecting or threatening his friends and relationships. Again, changes should be initiated in areas where they are easiest to bring about. Gradually more difficult changes could be attempted, the easier ones having provided a foundation for the more difficult ones. Initially he could give those he helps small degrees of responsibility in carrying out the tasks ("Let's do this part together . . ."). This degree of assigned responsibility would increase as time went on, with Curtis moving from the role of worker to co-worker and finally to consultant. The change would be gradual enough to avoid any excess discontinuity. Suggestions at progressive stages would perhaps take the form of, "Why don't you do this part while I work on the rest?" "I'll be glad to help if you can do such-and-such," and finally, "This is how you can do it—begin with this, then do that. . . ."

## Adaptation and Expectations of Reward

With both Christine and Curtis, we observed a certain difficulty which is caused in part by sudden large deviations about a habitual level. Both had established a relatively high level of expectation from which they found it very difficult to deviate by occasional refusals. Such refusal seemed too dramatic a change and therefore one which would not be tolerated by others.

This unexpected refusal, the sudden and large deviation from the

usual, is subjectively experienced by others as a very high negative reinforcement, a phenomenon which can be understood in terms of Helson's concept of *adaptation level* (27).

According to this concept, a human being's judgments are generally relative, even in such seemingly objective tasks as guessing the weight of objects. Once we are used to a certain level of stimulation, we adapt to it and make our judgments about that baseline. So, for example, if we give someone a one-pound weight after he has handled a series of weights in the ten- to twenty-pound range, he is likely to underguess it. But if we hand him the same one-pound weight after he has handled a series of weights varying around one pound, his judgment will be more accurate. Accordingly, Christine and Curtis' refusals were viewed as far more negative and extreme than would have been the case in a setting where refusals were rather common. The theory thus suggests that someone who is refused one out of three times will experience refusal as a much smaller negative reinforcer than someone else who is refused only once every twenty times.

### Determining the Expected Rewards in a Relationship

It is seen, then, that setting the initial level of reinforcement extremely high causes distress if one can't consistently maintain it, and disappointment in others when he fails. On the other hand, the choice of a very low level is not conducive to the development and maintenance of relationships. It is therefore more satisfactory to set the average at a realistic, intermediate level which one is capable of maintaining.

Determining this initial level of reinforcement is frequently an intuitive process. Very few of us deliberately structure our relationships to minimize difficulties at subsequent stages. Like Christine or Curtis, most of us leave it to chance or to the other person in the situation and then encounter difficulties because of unforeseen and undesired expectations or demands which arise.

*Pogo: In a group situation I often come off as a clown. This makes people like me, but only superficially in most cases. I feel the role I play is necessary for the good of the group, but I am often mad at myself afterward for doing it, as I would sometimes like to be accepted as a more understanding and sophisticated person. This causes serious conflict for me.*

Pogo sees himself as having only two alternatives, being a clown or being an understanding and sophisticated person. Choosing the clown role, especially when he first meets people, might be more reinforcing, which helps to explain his conflict or inability to change. His clowning probably draws a lot of attention and laughter (positive reinforcement) from others. He gains ready acceptance in new groups by being a source of amusement. But as time goes on the role becomes taxing, possibly because others are satiated with his antics and thus don't appreciate or reinforce him as much. Also his established image prevents people from taking him seriously. If he were temporarily to assume a more serious role, others might construe it as a sign that something was wrong, that he was unhappy or displeased with them; that is, negative reinforcements would occur in their relationships. It becomes difficult for him to shift roles once these expectations have been established, and it is at such times Pogo realizes that being funny is no longer rewarding.

If Pogo finds it difficult to behave in any other way when he encounters a new group, he might try to observe others for awhile, modeling some of their behaviors which he finds particularly appealing. In this way he could develop a list of more "serious" behaviors, rate each in terms of how comfortable it would be for him to behave in that way, and then select some of the easier ones to try out in a new group setting.

Such a change would of course make Pogo initially less reinforcing to others and provide him fewer reinforcers in return. The levels of reinforcement would be moderate rather than high. But the initial loss both ways would gain him the privilege of assuming a greater diversity of roles with his friends later on.

Meeting initial encounters with more varied reinforcing behaviors can lend added freedom of action to many simple, everyday aspects of social relationships. For example, punctuality is generally desirable, so we can assume that arriving on time for an appointment is more positively reinforcing to another person than being late. Now, on most occasions it is reasonably acceptable to be off the mark by a quarter of an hour, but socially "legal" deviations notwithstanding, some people are consistently punctual, and thus highly reinforcing to others. Once such an expectation of punctuality has been established, occasional tardiness is interpreted as a personal affront—or, at least, it is viewed as more negative than it would have been if tardiness were more common. In contrast a person who has been

somewhat variable in attending to his appointments can comfortably continue to be that way without distress since people don't think of him as punctual and don't make much of it when he is late.

An individual who selects a particular alternative where more than one is available, such as deciding to be strictly on time, may do so because it is initially more reinforcing to him and to others. But if it becomes difficult to maintain, both he and others may experience distress. Of course, someone might also select the opposite extreme which isn't reinforcing for anybody. This would be the case if one were consistently and irritatingly late for every engagement. A third individual who selects the more variable pattern receives only moderate reinforcement, but in exchange is allowed greater freedom and a role which is more comfortable to maintain.

### Development, Effort, and Ambiguity

An additional determinant in our choice of reinforcement in a relationship is how we view the other person—as a static, unchanging entity or as a developing one. For a relatively stable and unchanging person, we can select some moderate level of reinforcement which is comfortable for us and satisfactory for him. Over the course of a relationship, the variations which may occur in our reinforcements would be random, that is, not explicitly designed to influence him.

In contrast, if the other person is one who is developing, then we may view our interaction with him as contributing to that change. We may thus wish to contribute, not haphazardly, but in a more constructive and deliberate way. This would be more the case when one is partially responsible for another's development—children, employees who are learning new skills, or students. In such situations, there is an interesting relationship between the average level of reinforcement toward others and the rapidity of their development.

If we are excessively positively reinforcing toward Prebyn, for instance, what happens? Anticipating his needs, satisfying all his wishes, and generally requiring very little effort on his part can have deleterious effects. One reason is that when we are very positively reinforcing to another, he is not given the opportunity to learn for himself and develop new skills. In terms of the concept of shaping, reinforcement is not made contingent on behavior and therefore learning is minimal.

To illustrate, suppose two people, Spoon and Spade, decide to

become roommates and only Spoon knows how to cook. At the initial stage of their relationship as roommates, Spoon can either establish his role as (1) the one who does all the cooking, or (2) the one who does the cooking a certain percentage of the time, depending on what is realistic and feasible (probably about 50 percent). In choosing the second alternative, Spoon must count on Spade's potential ability to cook, as well as on his own ability to tolerate Spade's occasional failures and to offer advice if Spade requests it. Still, this choice is more beneficial to both of them in the long run; it permits Spade to learn a new skill and does not limit his potential capacity to develop or contribute to the relationship, and it also prevents Spoon from being saddled with an unfair share of the responsibility.

While cooking may not be a critical example, there are other situations where giving a partner free rein to develop certain skills, rather than assuming them all oneself, may be very important to the relationship. For example, if one partner in a marriage assumes the responsibility for making all their social contacts, it limits the possibility that the other will also contribute to the resources of their social life or develop his own social skills.

This principle can also be applied to child rearing. When a child who is overgratified in his family setting, experiencing little or no frustration, moves out to the community or school setting and meets frustration or punishment, he will probably react emotionally and his learning will be disrupted. If, in contrast, a child receives a very low level of reinforcement, he will be unable to develop because there are too few reinforcers to make shaping possible.

Another undesirable kind of early environment for a child would be one where the reinforcement is random. When the child's behavior has no effect on the occurrence of reinforcement, superstitious and unrealistic behaviors can develop. More generally, certain ritualistic or stereotyped behaviors are classified as superstitious since they have no correlation with their consequences, that is, they are not effective in consistently bringing reinforcers. These behaviors are best understood in terms of their probable maintenance by inadvertent and intermittent reinforcement.

Skinner has demonstrated the development of ineffective superstitious behavior with animal subjects (55). He placed hungry pigeons in a cage and reinforced them with food pellets every fifteen seconds, regardless of what they did. After a length of time, the pigeons began to show certain ritualistic behaviors, such as swinging the head or

turning in circles, all of which had been accidentally shaped and were occurring often enough to be intermittently reinforced by the food pellets. Of course, the use of a fifteen second interval helped the development of superstitious behavior, because reinforcement occurred so frequently that some behavior was very likely to be accidentally reinforced several times and therefore maintained.

It appears, then, that for a child also the random quality of important reinforcers can lead to superstitious behaviors. When reinforcers are given irrespective of the child's behavior, then he has no realistic means for controlling what he gets. The reinforcement contributes to the increase of the behavior which immediately preceded it, and so the behavior which is accidentally reinforced is frequently of no adaptive value. In this way, a particular behavior is accidentally reinforced and becomes more frequent, and is then more likely to be accidentally reinforced again. So some insignificant behavior is shaped inadvertently with the use of a variable ratio schedule. Let us say the child was physically tense when the parent was suddenly very reinforcing. He may continue to be tense and be accidentally reinforced again, and so forth. In this case bodily tension becomes the "superstitious" response. Such a response is not only bizarre but can often hinder learning of a more useful response.

More generally, then, it is possible that either useful (ultimately reinforcing) or useless (ultimately not reinforcing) behaviors can be learned and maintained on a variable ratio schedule, even when the reinforcement is random. In a situation where, among many possible behaviors, only a few are useful, there is a good chance that random reinforcement would lead to the development of some useless behaviors which might be detrimental or, at best, wasteful (28).

Incidentally, certain less obvious physical reactions, such as muscle twitches or heart rate, can be shaped in this way, without Prebyn being aware that it is happening (11). In one experiment, a very small muscle twitch in a subject's hand helped him avoid a burst of noise while he was listening to music, and recurred systematically without his awareness (26). When superstitious responses happen to be inner physiological reactions rather than outward behaviors, they are more difficult to detect and change.

A similar explanation underlies other superstitious behaviors and rituals seen in sportsmen. Your neighbor insists, "I can't putt right without my plaid hat on." A pitcher performs a variety of acrobatics as he prepares to pitch the ball.

We have now seen that excessively high or low levels of positive reinforcement or random reinforcement are not desirable. Rather, a moderate level is required which is contingent upon Prebyn's behavior.

Another way to view the average level of positive reinforcement toward a developing individual is in terms of the converse—that is, the level of demand or effort expected of him. If a parent is excessively reinforcing toward a child, the child infers that he is expected to exert a minimum of effort or tolerate a minimum of the discomfort which may be associated with learning (40). For instance, when a child is struggling to tie his shoe lace, some people may find it easier to help him than to wait and watch him flounder. However this reaction, if consistent, begins to define a certain relationship vis-a-vis the child: "I will take care of whatever things you have trouble with." If one can instead wait and then reward the child when he has made some progress, a different kind of role is communicated: "I know you can do things for yourself and I am also very pleased when you do so." The opposite approaches expressed in these two attitudes can have a critical effect on a child's rate of development.

Consider a teacher who takes on the very active role of presenting facts to the student, who in turn is requested to remember and reproduce these. This situation requires relatively little effort from the student and is patterned such that it is impossible for him to diminish the gap between his level of skill and that of the teacher. He is assigned a certain well-defined role to which his efforts are confined. In an alternate teacher-student relationship, the student would be required not only to take in the materials presented but also to question and even attack the teacher's position. Thus, with increasing development, he could take on more and more of the teacher's skills and actually act like a colleague in the learning situation. Such methods may be far more exacting for both student and teacher; however, they are ultimately far more gratifying to both, because the student gradually moves from a subordinate intellectual position to one that is comparable to the teacher's in his approach to the topic. This strategy also shows that if one can refrain from defining limits for the efforts of another, then the person being influenced has no tangible guidelines which dictate when he should stop exerting effort, or stop developing.

By not setting an upper limit for performance, development and growth can be reinforced positively in a context which does not

curtail the ultimate level of success that might be attained. This would constitute an argument against the assignment of fixed roles in situations in which people work or live together.

Employer-employee relationships are one class of situation in which the degree of initial role definition can be quite critical in determining productivity and the general quality of the work environment (pleasantness or cooperation). For example, an employer may delegate a minimum amount of responsibility and continuously define what the employee is expected to do. Once this pattern is established, the employee will adapt to it and begin to require constant direction, no doubt in turn confirming the employer's expectation that he is not capable of independent responsibility. As a result the employee will function below his potential and the employer will derive less benefit. On the other hand, once the employer has determined the employee's skills and capabilities, he can delegate commensurate responsibility without clearly defining the extent of that responsibility. In this case, the employee will be functioning relatively close to his maximum potential and the employer will in turn benefit from his greater productivity.

One of the difficulties in implementing the procedures discussed above is that some people become anxious or uncomfortable when they are expected to determine their own roles. When this happens, one can either provide the individual with an extensive interpretation of his role, or preferably define only part of what seems to constitute that role. Once the faltering individual begins to function and produce, it is easier to increase or decrease expectations on the basis of his actual performance.

The preceding examples illustrate how an initial definition of roles or of expected reinforcers (that is, the amount of effort expected from the partners in a situation) can have a dramatic effect on subsequent individual development or roles within the relationship. It is interesting to observe how different cultures or subcultures assign markedly different roles and expectations to the maturing individual. For example, in certain subcultures a child may be expected to exhibit a higher level of intellectual or physical accomplishment than others. Erik Erikson reported how an entire Indian family sat watching a young boy take several minutes to close a large heavy door (15). The patient and accepting attitude of the elders allowed him to keep trying, and when he succeeded they praised him. Likewise, it has been the custom among some people to give an elaborate feast to

celebrate the first time a young son shoots a bird or mammal. These illustrate a relatively high level of expectation for development of physical skills and a culturally prescribed tolerance for failures and ambiguity.

## SUCCESS, FAILURE, AND CENTERING

In most learning situations, success and failure are subject to interpretation. Consider someone who wishes to stop smoking cigarettes. He manages to abstain for about a week or so but then resumes smoking and views the entire attempt as a failure. Of course he also could have viewed the attempt as partially successful since he did indeed stop smoking for a whole week. There are some people who, in such ambiguous situations, tend more often to consider themselves as failures then as successes, and likewise there are others who typically distort in the opposite direction and think of themselves as primarily successful.

Another subtlety in the application of reinforcement theory is knowing when it is appropriate to induce someone to focus more on his successes than his failures, and vice versa.

One person's interpretation of another's success or failure is a social reinforcement and of course varies in potency depending on who does the interpreting. If it is a respected or liked person, then his opinions may have dramatic effects on the learner's subsequent behaviors.

Since people are more likely to continue exerting effort when they are positively reinforced, it follows that, within limits, successful behavior change is more probable when efforts are optimistically interpreted as successes than when they are interpreted as failures. So, in the case of the cigarette smoker who stops smoking for a week and then resumes again, if he or others interpret the episode as a success then he is more likely to try again and possibly abstain for an even longer period of time, and so on; if he considers the episode a failure then he is less likely to try a second time.

In this context it may be of some interest to consider the idea of "self-fulfilling prophecy," which asserts the greater likelihood of something actually coming true when it is expected. Whether something "actually comes true" is also subject to interpretation, and if we expect it, we may be prone to interpret an ambiguous outcome as conforming to that expectation. For example, someone who wants

to stop smoking may say, "I'm bound to fail," or others may say this about him. If and when he resumes smoking, the entire attempt, consistent with the prediction, is regarded as a failure rather than a partial success.

A second aspect of the self-fulfilling prophecy is its role in perpetuating unrealistic or superstitious beliefs. Consider superstitions such as, "It's bad luck for a black cat to cross your path," or "If you recite this Indian chant you'll get whatever you want and really be happy." Since the outcomes in both these instances are quite ambiguous (what is bad luck, or what exactly is "happy"?), it is relatively easy to interpret them in a way which is consistent with, and reinforcing to the superstition. Occasionally after a black cat has crossed, some clear-cut disappointment may actually occur, or after the chant has been recited something clearly pleasant happens. Such occurrences help considerably to strengthen the superstition. So, in addition to the freedom to interpret outcomes in a manner consistent with a superstition, there are occasional unambiguous outcomes which help to reinforce and maintain such beliefs.

## Centering

Centering, introduced by the Swiss psychologist Jean Piaget, is a more general concept which subsumes the preceding variant of social reinforcers (49). It refers to disproportionate emphasis on a certain part of a situation. For example, when one asks a friend to notice a certain element in a painting, he is encouraging him to center by directing and maintaining his attention on, say, color to the neglect of shape, composition, or subject matter.

Performance in a learning situation can be viewed generally as a stimulus with many parts. When a person encounters such a complex stimulus, it is possible that he will focus disproportionately on certain aspects of it and thereby disregard others. We have noted how individuals vary in their direction of focus when they encounter complicated events—some are relatively prone toward optimism or pessimism, while others are generally objective, taking into account both their successful and unsuccessful efforts. The former ignore a large portion in their process of centering or focusing on only a few components which they are familiar with or which arouse certain strong feelings in them, and this produces behaviors which are not necessarily representative or adaptive.

Centering can be both beneficial and detrimental in a learning

situation. It all depends on how frequently, and at what stage of learning, it occurs. When we consider some of the pathological phobic reactions in the next chapter, we will notice that a phobia frequently involves disproportionate centering on a stimulus which the individual fears intensely. His centering prevents him from noting other aspects of the feared stimulus which can elicit new and more constructive responses. Thus he continues with rigid avoidance of the situation.

There are also some cases where it is just as harmful to center exclusively on the positive aspects of a situation. Witness:

*Gunga-Ho: Whenever I first meet someone I like, I tend to become overly enthusiastic about him. But I lose this feeling in a very short time, and the result is always a kind of general disappointment in people—a feeling I would very much like to avoid. I would rather be able to be more reserved in the beginning and then be able to grow in my liking as time goes on.*

Excessive initial centering on the more desirable qualities of those one meets can lead to an unrealistic set of expectations, and from there to disappointments when people cannot consistently measure up. But excessive pessimism can be just as maladaptive as Gunga-Ho's optimism in its effects on interpersonal relationships: while the former leads to disappointment, the latter can lead to avoidance and cynicism.

Gunga-Ho can partially counteract his difficulty by writing down his impressions following an initial encounter, striving to note both positive and negative qualities. This would minimize the possibility of his dwelling on only the one or two characteristics which make a particularly strong impression.

Centering, further, is a basic principle in the realm of advertising. By extolling the virtue of one aspect of a product, an advertisement induces the audience to center on a certain component of a complex situation, minimizing attention to many other components which may be equally or even more important. Again, this may or may not be to the advantage of the buyer. When some competing products are similar in price and quality, the fact that one comes in "decorator colors" may make a significant difference to the consumer. But the fact that Kissum toothpaste gets your teeth whiter and brighter, though true, may not seem so enticing when it is known that its extra strength could also be destructive to tooth enamel. Our vulner-

ability to centering is further evident in that we often buy something only because the ads attracted or entertained us, the product's own qualities being virtually irrelevant.

### Centering and Social Reinforcement

One social reinforcement technique, where the trainer or therapist deliberately interprets success and failure, illustrates the possibility of creating an environment which directs people to center on parts of a complex situation. For instance, in any kind of learning situation, centering may be used to the student's advantage. Suppose a child who is learning multiplication misses three-fourths of the items on an exercise. This outcome may be structured either as success, failure, or a combination of both. If a child becomes very anxious and uncomfortable in the face of failure, it would be better to center on every small indication of improvement with a continuous reinforcement schedule. But if the child in question is not excessively upset by failure, it would be possible to shape his learning with a variable ratio rather than a continuous reinforcement schedule.

In a sense, then, shaping involves centering on success. Its effectiveness suggests that it is more beneficial to center on success than on failure, and that this is especially important with certain individuals for whom failure discourages persistence. By frequently centering on the success component, one can encourage such persons to continue their struggle with a problem. Even in such cases, as shaping proceeds, the trainee becomes more confident and a shift to variable ratio schedules is possible.

Centering on the negative elements of events, both at the individual level and in group relationships, can frequently lead to a vicious cycle of pain and failure. People who are forced to interact in such situations see the relationships as primarily negative and are discouraged from developing new means to counteract some of the problems involved.

Applying this concept to relationships between subcultures within a society, we can see that news media can play an important role in determining whether such a vicious cycle is perpetuated or broken. For example, in covering problems of our major urban areas, the press has perhaps contributed to the maintenance of hostility and bad feelings by emphasizing situations of conflict and disturbance between police and minority groups.

However, recent trends suggest that responsible members of the

news media are beginning to recognize the need to emphasize positive accomplishments. They often give free publicity for benefit events sponsored for underprivileged areas and bring to the forefront other instances of growth and progress in these areas. A general turn toward positive centering would probably help to improve most cities and the lot of those critically involved in the problems. Further, at certain times it is especially appropriate to minimize anticipation or elaboration of small incidents which can be construed as negative. This is not to say that we should bury our heads in the sand, but rather we should lean toward positive newscasting as a means of reducing irrationality and disruption prior to a potential crisis.

## SUMMARY

This chapter examined the nature of rewards. Successful reinforcement requires rewards which can be used in many settings and which can be given immediately after the desired behavior occurs. They should also continue to be rewarding for Prebyn even when he receives them repeatedly. Social reinforcers, when used flexibly, can fulfill these criteria. They are defined in two ways: (1) communicating greater degrees of liking, interest, or warmth to another through assuming a closer position to him, touching him, looking into his eyes, leaning toward him if seated, assuming moderately relaxed postures, using more immediate speech forms, avoiding interruptions, and using positive intonation; (2) communicating respect by agreeing with someone (such as by head-nodding or "uh-huhing"), not interrupting his speech, facing him directly rather than sitting beside him, looking into his eyes, and being slightly less relaxed than one would be with a peer.

Since different degrees of like and dislike can be conveyed in different behaviors, we also considered the impact of combinations of behavior. Listed in order of importance, some of the behaviors that communicate liking are touching, facial expression, intonation, posture, and words. When combined inconsistently, a more important behavior would of course dominate and determine the total message; for instance, when the facial expression communicates liking and the words communicate dislike, the total message is one of liking.

One central problem of social reinforcement is when to use the more subtle nonverbal or implicit reinforcers instead of simply asking Prebyn to change. Telling a person that he will be rewarded for cer-

tain behaviors should be at least as effective as telling him nothing—the obvious and major exception to this being when Prebyn finds others' influence intensely repugnant. It therefore helps to know in which social situations influence is a well-accepted part of human interaction and in which it is inappropriate. For instance an employee may resent deliberate attempts of a co-worker to influence him, whereas a typical student would not resent being influenced by his teacher. If, due to his resentment of authority, Prebyn resists verbal influence even under legitimate circumstances, then subtle reinforcers are more appropriate.

We also discussed the frequency of the rewards a person receives relative to his rate of development. Both very high and very low levels of reinforcement are undesirable. When very few reinforcers are given a person, he develops slowly; shaping requires frequent reinforcement. When too many reinforcers are given, Prebyn receives reinforcement unrelated to what he does—that is, there is no shaping. Also, a very high level of reinforcement may be difficult to maintain and may thus lead to disappointment, and disruption of the relationship. Moderate levels of reinforcement are the most realistic because they are easy to maintain without causing deprivation for Prebyn or extreme discomfort for Ragent. A variety of difficulties can be avoided if Ragent takes a more deliberate tack and determines his level of reinforcement toward another during the initial stages of a new relationship.

Finally, success and failure are subject to interpretation, and it is more advantageous to center on success than on failure. That is, it is better to err on the side of seeing another's behavior as at least partially successful, than to err on the side of being too critical and seeing it as a failure. The effectiveness of shaping techniques is ample evidence for this assertion, for shaping involves an emphasis on the positive reinforcement of even slight improvements.

# TEMPERING
# THE
# ENVIRONMENT

## CONDITIONING

We can now consider some ways in which one can control his own or another's behavior by modifying the arrangements or sequences of stimuli which are likely to influence those behaviors. The general effects of stimuli on behavior need to be considered, before changing environments to influence behavior, can be discussed.

Every stimulus elicits a response; thus every behavior could be seen as a response to some stimulus. This relationship is easily observed in the case of certain almost reflex-like responses to various situations. Fear and its physiological concomitants in

99

reaction to threatening stimuli, or salivation in response to desired foods, and so forth, illustrate unconditioned responses. But there are also countless stimuli which do not automatically elicit the same response from everybody. How can we understand the reasons that different people react differently to the same stimuli? The answer to this can be found in the history of co-occurrences of certain pairs of stimuli in each person's background.

The Russian psychologist Pavlov observed that when dogs were consistently presented with food and this event was accompanied by the ringing of a bell, the dogs eventually could be made to salivate by the ringing of the bell by itself. Somehow, pairing the bell with the food had transferred some of the properties of the food to the bell, such that the bell could elicit salivation.

This process involves an unconditioned stimulus, food, which elicits a certain response, salivation. The food is then paired with a conditioned stimulus, the bell. Through this association, the bell begins to elicit the same response, salivation. To "condition" a response, then, means to present a stimulus that does not at first elicit the response, and follow it regularly with the unconditioned stimulus, which does produce that response, until eventually the conditioned stimulus alone comes to elicit the response.

Let us briefly summarize these terms. There are unconditioned and conditioned stimuli. Unconditioned stimuli are those which, in the absence of any learning, elicit a characteristic response; for example, shock elicits pain. Conditioned stimuli, however, are those that begin to elicit a particular response only after learning. The kind of learning in question is called conditioning: if we repeatedly pair a new stimulus with one that has in the past elicited a certain reaction from a person, this new stimulus alone eventually begins to elicit that same reaction.

It follows from these concepts of conditioning that every behavior is elicited by a certain stimulus, unconditioned or conditioned. In the presence of that stimulus the behavior occurs; in its absence the behavior does not occur.

Let us now consider an additional aspect of conditioning. In the case of the bell, the dogs could be conditioned to a tone of a certain frequency (pitch). Upon hearing that tone, the dogs would salivate. But would it make any difference if we changed the pitch upwards or downwards? Experiments have shown that the closer the pitch of the new bell to the one that was used originally, the more similar

the response. In this case, as the pitch becomes increasingly dissimilar to the conditioned one, the incidence of salivation becomes less frequent. This phenomenon is termed *stimulus generalization*: When any stimulus elicits a response, stimuli that are similar to it also generally elicit that response. The more similar a stimulus to the original one, the more likely it is to elicit that response. Thus, when a response is measured in terms of its intensity, the greater the dissimilarity between any stimulus and the conditioned one, the less will be the amount of the response.

Stimulus generalization, then, explains how, when a person has learned a response to a given stimulus, he produces it not just for that particular stimulus but for a series of others like it. The "catch" of course is that a person may sometimes generalize a newly learned response too far, by reacting to some similar stimulus with the newly learned response when it is not really appropriate. A familiar example is a young child who is frightened by a neighbor's dog. Because of stimulus generalization, he thereafter becomes afraid of all dogs.

The process used to teach someone to counteract excessive generalization is known as *discrimination learning*. The subject is taught to respond differently to two stimuli which are within the same class but which differ in intensity, or some other quality. In the case of the dogs, a tone of a high pitch may be conditioned to feeding and one of lower pitch conditioned to shock. The animal quickly learns to salivate in response to the high-pitched tone and to lift his foot up to avoid shock in response to the low-pitched tone. The next question is, how far does each of these two tones generalize? The animal will respond appropriately until we select tones very close to the middle of the range between the low- and high-pitched tones, at which point he will become confused. In the same way people can be taught to counteract generalization by learning to respond differently to various ranges of any particular stimulus.

Let us see how these concepts of conditioning are applied. Have you ever wondered how a person acquires an intense dislike for a certain food, color, or situation? Dislike for a food may have been acquired during a single experience when perhaps one ate the food while feeling sick, or while experiencing extreme emotional distress, such as an unusual argument in the family. The reactions which were elicited by the unpleasant stimulus (illness, distress in the family), became associated with the food, thereby transferring negative reaction to the food. Through generalization similar foods also come

to be disliked. Sometimes, too, it could be a simple case of eating spoiled food which elicits a negative response. Thereafter the dislike is generalized to that food and others similar to it. Intense dislike for a particular color or any other object can come about in much the same way.

The following case illustrates one of the variety of situations in which conditioning can be used to induce change (16). Oedipus, a boy of ten, would frequently wake up frightened in the middle of the night and run to his parents, wanting to get into bed with them. His parents had tried different methods to change his behavior but had been unsuccessful. Their lack of success may have been due to an unsystematic use of positive or negative reinforcers. On one occasion when Oedipus was forbidden to come into his parents' room, he spent four hours crying outside the door. As this problem persisted it created several difficulties and tensions in the family.

Oedipus was brought to a behavior therapist, who first established that his behavior was due to his fear of being alone in his own bed. Next the therapist attached electrodes to Oedipus' arm and asked him to imagine himself in his mother's bed and to say aloud, "Mother's bed." Just as he said it, he was shocked mildly. Then he was asked to say, "My bed," for which he received no shock. These two steps were repeated several times until the idea of being in his mother's bed became associated with an unpleasant emotional response, while the idea of being in his own bed was associated with relief from the unpleasant response. This simple application of conditioning principles was effective—Oedipus stopped disturbing his parents at night, and a number of related difficulties within the family were resolved.

One might object that Oedipus was merely conditioned not to think about being in his mother's bed and that the physical response of getting up and crying at the door in the middle of the night was something different and could persist. The relationship between the thought of being in mother's bed and actually approaching mother's bed is understood in terms of the concept of stimulus generalization. In fact, the effectiveness of the method hinges on stimulus generalization: the thought of being in mother's bed is conditioned to be negative, and actually being in mother's bed also becomes negative, through generalization. If difficulty had been encountered, then generalization could have been facilitated either (1) by using a more painful stimulus in the conditioning, or (2) by negatively conditioning

thoughts and actions that approximated, in increasing degrees, the actual behaviors of Oedipus.

## STIMULUS CONTROL

Stimulus control is another application of conditioning. It is based on the idea that individual responses are conditioned to, or associated with, specific stimuli; the occurrence of a particular stimulus consistently triggers a certain response. An obvious implication here is that if one desires certain behaviors to occur more often in the future, then he must create a stimulus environment which is conducive to the occurrence of those behaviors; or to diminish undesirable behaviors, he needs an environment which will elicit responses other than the undesirable ones. Stimulus control can help one change his own behavior as well as that of others.

Before psychoanalysis, doctors would prescribe rest and a vacation for anxious patients whose physical condition did not account for their psychological distress. Such advice can be seen as an application of stimulus control. A restful and pleasant environment elicits both behavioral and physiological responses which differ from tension and anxiety, and thus could at least bring about temporary relief.

### Working

Recently a friend, Professor Uni, mentioned that it had become very difficult for him to get any writing done in his office since he was constantly being approached by students, laboratory assistants, or colleagues. He attempted to work on his manuscripts at home, but found that that environment somehow discouraged concentrated effort also. In both places there were too many distractions interfering with his work. So he selected a relatively secluded part of his home and made it into an office. He even went so far as to dress in a suit and tie when he worked there, just as if he were at work. Having created what was for him a work-like, yet undisturbed, environment, he was able to write successfully at home.

Let us analyze the procedure which Professor Uni intuitively applied to resolve a problem of minor difficulty. The home environment included many stimuli which are associated with activities other than work, such as eating, listening to music, conversing with children or wife, etc., but little stimulus for concentrated working and writing. Further, his informal dress was, for him, suitable to working in the

yard, playing with the children, going for a walk, but not for being a disciplined writer. His solution was to select a room in the house which permitted him to escape the normal household noises and distractions, and to select a decor which did not permit a great deal of relaxation or elicit the thoughts associated with reclining chairs, couches, paintings, books, magazines, etc. He chose to dress just as though he were at work, which helped to produce the physical and emotional feelings he typically experienced while working. He made these choices in order to maximize the cues which he associated with work and to minimize the cues from home which he associated with family and casual activities.

### Dieting

Professor Uni's example illustrates how a limited portion of one's environment can be deliberately structured to encourage particular behaviors. Another good example is eating. Many Americans have difficulty regulating their diets due to an abundance of food and a high level of physical inactivity. Stimulus control might be of great assistance in regulating eating. For example, suppose most eating is done at home. If a specific diet is being used, stocking only the permissible items can be a critical factor in the success of the diet. If a person can limit his purchases to only the "skinny" foods he is permitted to eat, then he would have to make a special trip to the store to transgress, or consume the forbidden foods in a restaurant or someone else's home. All these alternatives require more effort than simply reaching into the refrigerator to get a forbidden item. Thus, exercising control for a short time, while shopping, makes dieting easier in the long run by eliminating the temptations to indulge.

"But," you might object, "this applies only to those living alone, and many, if not most people who live alone probably do not eat most of their meals at home. Isn't there some modification of the 'food stocking' technique for those whose families like lots of 'goodies' in the cupboard?" The goodies are usually consumed by children who can afford to be less concerned about dieting. But they would probably be more than happy to consume their goodies to the point of satiation in the neighborhood drugstore or ice cream parlor. Single people who eat in restaurants can use the somewhat less effective modifications of the basic technique given below.

It is further possible to control the desire to purchase the for-

bidden foods while shopping. Hunger is the key determinant here—
it is a stimulus of overwhelming impact in determining not only
what we eat but also what we buy. It generates certain not-to-be-
ignored response patterns. The food-purchasing behaviors of a hun-
gry person are much more likely to sound like "I love this, I'm
going to buy some" (a set of responses to hunger learned in the past),
than "This is good for me whether I like it or not, so I'll buy it" (a
more recent dietetic restriction on his established likes and dislikes).
If the immediate and demanding influence of hunger is absent, then
it is easier for the more rational dietetic limitation to take precedence
in determining the purchases we make. It might therefore be wise
for the person on a diet to go shopping right *after* a meal rather
than before. (Incidentally, this can be suggested as good policy for
economy-minded housewives as well, even if their families aren't
dieting. It makes a surprising difference in the food bills.)

If controlling our stimulus environment for eating at home can be
frustrating and difficult, it is even more of a problem when we are
visiting others or dining out. People who typically eat in a variety of
environments, therefore, must use slightly different versions of the
above technique. For instance, rather than ordering a meal as is,
with the good intention of ignoring the fattening elements (the
baked potato, the hot buttered rolls), one can simply request that
the waiter not bring those things to the table. He is then structuring
his immediate environment as much as possible to avoid the potent
temptation of seeing forbidden foods in front of him. Controlling
meals in restaurants, however, is more limited in scope and effect
than the instance where the foods made available in the home are
carefully selected. The greater limitation in the restaurant is that
structuring of the environment is required on each eating occasion,
whereas at home a single shopping trip can influence many eating
occasions. Thus, generally it is preferable to design situations which
more frequently exert influence on the behaviors in question.

There are three general guidelines for the use of stimulus control:
(1) arranging an environment in advance to influence the occurrence
of certain behaviors (58), (2) doing this arranging on as broad a level
as possible, to exert the most influence with the least effort, and
(3) arranging the environment when the related internal stimuli
(feelings) are minimal. This third guideline allows the arranging to be
done in terms of a predetermined plan rather than by strong feelings
which automatically lead to certain of the undesirable behaviors.

## Sleeping

Stimulus control might also be useful with children who have difficulty going to sleep. Sometimes a child of five or six "can't sleep" when he goes to bed but talks to his siblings, returns to the living room to see his parents, or requests a drink of water. If a child shares his bedroom with other children, or with toys and other stimuli typically associated with play and waking activities, the environment will discourage sleeping. It may be effective to isolate the child in a separate room of his own which contains minimal cues related to daytime activities—no toys, no brothers and sisters who might elicit behaviors which prevent settling down to sleep.

## Studying

Another use of stimulus control pertains to students and the perennial problem of studying. Students who need extended periods of concentration frequently find it difficult to study because of various distractions. The following statement is typical:

*Wendell: My biggest problem is lack of good study habits. I am easily distracted by my roommates but would like to correct this situation without antagonizing either of them. I prefer studying at home rather than in the library, but constant small interruptions—needless questions or just general talking—interfere with my concentration. Both roommates study well when it suits them, but sometimes show little consideration if I am busy and they are not.*

Stimulus control for Wendell involves selecting an environment which he knows is conducive to concentration and making it a point to seek out that environment for studying. The person who has trouble concentrating needs to recall those places where he was able to concentrate successfully in the past and duplicate them as nearly as possible. This is entirely an individual matter—for some it may have been a private room at home, for others the school library or an empty classroom.

## Creating

There are other, more subtle applications of stimulus control. It is interesting to examine the environments which artists, writers, or

musicians design for themselves in order to enhance their creative process. Some of them are quite unusual. The parts of such an environment are generally intended to stimulate or bring forth certain associations and trains of thought. A painter might like a certain type of background music because it stimulates his visual imagery; having a variety of art objects around might serve to set up associations for a writer or a musician. Some find their inspiration by mixing with many people, others by being alone with their thoughts.

The environment can be designed to provide a rich source of associations which may be disjointed or even arouse contradictory feelings and thoughts. Part of the creative process would then include some integration or harmonizing of these contradictions in the form of a painting, composition, or piece of sculpture. We must stress the totally idiosyncratic quality of such stimulus-association links—what serves as inspiration to one person may mean utter disruption to another.

Stimulus control can be seen as an elementary but useful tool for influencing behavior. Application is limited, of course, to the extent to which a variety of behaviors are possible within the same environment. So the more drastically an environment limits a class of behaviors, the more useful it is for stimulus control of those behaviors. Further, although one environment can generally be expected somehow to limit the behaviors of most individuals, there will always be differences in the effects that the same stimulus has on different people's behavior. As a consequence, the stimulus control technique frequently needs to be tailored specifically for each individual. An adult, on the basis of his past experiences, may be the best judge of which environments can best encourage or discourage certain of his own behaviors. For children, or adults who find themselves helpless in a given situation, another person who knows them well could select an appropriate environment.

## RECIPROCAL INHIBITION

In their classic experiment, Watson and Raynor presented "Little Albert" with a white rat and followed the presentation with a sudden, loud noise from behind which frightened him (62). After this sequence was repeated only seven times, Albert was terrified of the rat by itself. This experimentally-induced phobia generalized to other furry animals as well, such as rabbits or cats.

Such a phobia can be removed by placing the child in his high

chair in anticipation of eating. He is then shown a rat or other small animal at close range, which of course elicits considerable fear. Next the animal is moved far enough away so that it is still in view, but the child's fear is attenuated. Then the child is fed. During the feeding the animal is gradually moved closer to him, the approach being gauged by his fear response (keeping it to a minimum). During the final step, the animal is placed on the child's table while he is eating, and he touches it and plays with it without being anxious at all.

How can we understand this whole process, the induction and removal of a phobia? The induction, of course, was a simple case of conditioning—a furry animal is paired repeatedly with a loud noise until the animal alone produces the fear response. Stimulus generalization would then explain why the child might come to fear other similar small animals. We have also mentioned that an unrealistic, maladaptive fear can be perpetuated because the person avoids the feared object as much as possible and thus has no opportunity to learn any new responses.

The development and maintenance of phobias can be explained as follows. Phobic avoidance of an object is reinforcing because it reduces fear. Thus, the sequence of development in a phobia is, for example, seeing an animal, experiencing fear, henceforth avoiding that animal or others like it, and experiencing some degree of reinforcement for successful avoidance—the reduction of fear. In this pattern, avoidance is shaped and maintained. With no guidance from others then, Prebyn completely avoids the animal or situation which he fears and does not learn that it is harmless. Such intense fear reactions, often conditioned to quite harmless entities, are frequently observed in clinical and experimental settings and were quite resistant to change until the following techniques were developed.

The technique of *reciprocal inhibition* has been found to be successful in counteracting such fears (65, 66). It requires a response (such as eating) which can inhibit the occurrence of the maladaptive response (such as fear). This technique was illustrated in the case above, where the eating minimized, or directly inhibited, the possibility of anxiety and fear because the pattern of autonomic (physiological) reaction associated with eating inhibited the autonomic reaction associated with fear and anxiety. This direct inhibition weakened the link between the feared object and the fear response, while simultaneously strengthening the link between the feared object and the relaxed and comfortable response.

The inhibition of the physiological responses associated with anxiety, due to eating, or conversely the inhibition of relaxation associated with eating, due to anxiety, is the basis for the name of the technique—reciprocal inhibition.

If relaxation and anxiety can inhibit one another reciprocally, then how can we be sure that relaxation will win over anxiety, rather than the other way around? To insure success, a situation is designed in which anxiety is initially very weak, as was the case in the child's gradual exposure to the feared rat.

If we had presented him with a continuous strong dose of the feared object by leaving the rat right in front of him, his fear would have been too intense for him to relax and eat. Thus he was first reminded of his fear by seeing the animal at close range, but it was then removed to a distance which diminished its threat. The relaxation associated with eating then helped the child counteract the weak fear that might have remained at that distance. Thus, the new response of relaxation was conditioned to the object while it was distant, and as it was moved closer the child continued to maintain his state of relaxation, through generalization. In this way the conditioned reaction of fear was gradually and completely removed.

There are many behaviors which can be used to directly counteract, or inhibit, the occurrence of anxiety. These include physical activity (preferably strenuous), self-assertion through mild expression of negative feelings toward another ("standing up for your rights"), and relaxation, which can be induced through eating, deep breathing muscle exercises, or perhaps tranquilizing drugs (30). Incidentally, the relaxation induced by eating may also increase the possibility of friendly and conforming reactions. The businessman's habit of negotiating over lunch is more than mere convenience.

## Areas of Application for Reciprocal Inhibition

It has been suggested by some behavior therapists that unrealistic fears or anxiety reactions are the essential basis of any neurotic or maladaptive behavior. If this were the case, then it would follow that all neurotic behaviors could, in principle, be treated with reciprocal inhibition. Rather than debating the validity of this conception of neuroticism for *all* cases, we will simply accept it as correct for a great many cases and will examine in some detail the application of reciprocal inhibition to a variety of situations. The techniques involved are useful, quite simple and easy to apply.

Linda was a little girl who, within the course of two or three weeks, saw a friend fall into a swimming pool and drown, lost another friend who died of meningitis, and witnessed a car accident in which one person was killed. She somehow associated these traumatic experiences with the absence of her mother at those times, and subsequently the absence of her mother elicited very strong anxiety reactions from Linda. Linda's therapist, after having established the cause of her fears, asked her to lie down, close her eyes and then imagine being separated from her mother for just five minutes. As he helped Linda to vividly imagine this situation, she was in a very relaxed state, and the relaxation helped to counteract or inhibit the anxiety stemming from the imagined separation. She was gradually led to imagine longer and longer periods of separation, but always while in a relaxed state. Following several sessions of this procedure, Linda no longer feared being away from her mother. As in the case of Oedipus, the effectiveness of Linda's cure hinged on stimulus generalization—from imagining separation from her mother to actually being separated from her.

The above technique involves inducing a subject to relax and imagine some weak but analogous version of the conditioned stimulus which elicits anxiety. Others involve hypnotizing the subject and presenting to him as vividly as possible the various stimuli which increasingly resemble the conditioned stimulus he fears.

Another important application of reciprocal inhibition is for sexual inadequacy which stems from tension or anxiety in anticipation of, or concomitant with, the sexual act. Such occasional anxiety can result in temporary frigidity or impotence. The tension or anxiety due to anticipation of sexual intercourse can readily interfere with or prohibit orgasm, induce premature orgasm, or impotence. Thus, any activity which can inhibit this anticipatory fear and tension, such as relaxation or a high level of sexual excitation, can be helpful. Specific techniques which have been used in such cases are as follows.

A couple whose sexual relations are inadequate is told to sleep together but forego sexual activity for a week or so. It is mutually agreed that during this period there should be no expectation of or attempt at the act unless and until the high state of arousal is attained. During the waiting period, the level of arousal builds, is maintained, and continues to inhibit tension and anxiety associated with being in bed and anticipating sex. This pattern is maintained through successive cycles until the accidentally-conditioned connection between anticipation of sex and anxiety is severed.

In considering the role of physical activity as an inhibitor of anxiety, we might wonder what happens to the soldier on the battlefield when he is confronted with a barrage of extremely noxious stimuli which would evoke high degrees of anxiety for most people. How is it that most soldiers somehow function without great distress in a situation which is so tense, violent, and alien to what they are accustomed to? First, there is a considerable amount of rehearsal and preparation in anticipation of the actual battlefield situation. Second, there is a high level of preoccupation with certain activities which tend to inhibit anxiety. Consequently, in a relatively brief period of time, the link between the noxious and terrifying stimuli and the response of anxiety is weakened.

When a person is so extremely anxious and agitated that use of the simple relaxation techniques does not appear possible, relaxation might be physiologically induced with tranquilizing drugs. In one case, a boy who was terrified of animals in general was given sedation for three days. Once he was relaxed because of the sedation, he was gradually exposed to various animals until he overcame his phobia.

Another case history report involves Ted, a child who became terribly frightened of any moving vehicles after having been in a car accident. He was helped with the relax-through-eating technique. For Ted food was used both as a reward for talking about cars initially and as a means of inhibiting his anxiety. The therapist began by making conversation with Ted, and after they had become acquainted and Ted was adjusted to the surroundings, the therapist briefly and casually mentioned something about traveling. Ted had been so upset and frightened that even talk about cars or moving vehicles of any kind had previously displeased him, so when he responded to the therapist's conversation by talking about a car, he was immediately rewarded with some chocolate. Once his talk about cars was reinforced positively, he began to talk of them more frequently, and the therapist continued to reinforce him with chocolate. Eventually Ted and his therapist were able to play games with toy cars and even have accidents with them—Ted eating chocolate all the while. They next progressed even further to sitting in a stationary vehicle, with Ted still eating chocolate. The next step was to make a brief trip to the store (eating more chocolate). Finally, after gradually taking longer trips, Ted overcame his fear of cars and traveling completely. Throughout, the candy served both as a reinforcement to encourage Ted's increasing involvement with cars, and as an inhibitor of his anxiety reactions.

### Forced Exposure

There are some situations which do not require a direct inhibition of an anxiety reaction, in which fear can be overcome by merely forcing a person into the presence of a feared object.

We have already noted that one prime reason for the maintenance of an irrational fear reaction is that the person learns to anticipate and avoid the feared object, thereby never realizing that his fear is irrational. Joseph Wolpe, one of the major proponents of reciprocal inhibition, conducted some experiments with cats which are of interest at this point. He first placed them in a cage and shocked them by passing a current through the cage floor. Whenever the cats were placed in the cage thereafter, they exhibited a fear reaction which persisted for several months, even though they were not shocked again. In this case where the initial stimulation was probably quite painful, merely forcing the cats into the presence of the feared stimulus was not sufficient to alleviate their fear of it (16).

Another researcher, Guthrie, suggested that if somehow, perhaps accidentally, a subject could be induced to produce a different response in the presence of the feared stimulus, then his second response would be retained until further new learning occurred and a third response was associated with the object (21). Guthrie called this a process of one-step learning and illustrated it in a large number of situations, one of which was the taming of wild horses. When a horse is mounted for the first time, it reacts violently. But if the rider can stay on top of him long enough, the animal changes dramatically and produces a novel set of reactions to the same stimulation, and those reactions are maintained without any recurrence of his initial disturbance.

Another way to understand such dramatic changes is that the anxious or disturbed condition is in itself negatively reinforcing for Prebyn, so if he can be forced to stay in a situation where there are actually no adverse consequences, then those disturbed behaviors, which are negatively reinforcing for him, will quickly diminish in frequency (57).

Wolpe's results with the cats might discourage one from hoping to achieve change with the use of forced exposure such as Guthrie suggested. But working with human beings does seem to provide a basis for change through forced exposure—change which can include

successfully overcoming maladaptive and unrealistic fears. Let us consider two examples.

Since snake phobics are relatively common, they have been the object of many experiments in the area of reciprocal inhibition. One of these involved fitting the phobic with electrophysiological equipment to directly measure his heart rate, blood pressure, and perspiration. When induced by the experimenter to hold a harmless snake, the physiological indicators showed a very sudden and drastic increase in anxiety. But within a short time the anxiety subsided to normal levels. In other words, holding a snake just briefly is sufficient to overcome the fear. Such a procedure would of course hinge on the experimenter's ability to induce the phobic to hold a snake. If he fails to do so he could resort to the technique of desensitization, which is considered in the following section.

Here is a second experience which provides support for the effectiveness of forced exposure. A friend and I took his young daughter on a sailing trip. Being a very well-behaved little girl, she initially said nothing to indicate her fear and discomfort, but after sailing two or three hundred yards onto the lake, we noticed that she was sitting by herself and crying quietly. Here we were then, two psychologists and rather poor sailors with a little girl in great distress. Our first thought of course was to be more attentive and consoling to her, to tell her there was nothing to be afraid of. But such a solution, as you may recall, would have partially constituted a positive reinforcement of her expressions of distress. Furthermore, our attentiveness might have focused her attention toward us, not allowing her to discover for herself if sailing was really so frightening. What we decided to do was to appear to ignore her distress and engage in a cheery conversation between ourselves, commenting on the pleasantness of sailing, the sound of the waves, the sea fragrances, the wind flapping in the sails—hoping thereby to attract her attention to these things without explicitly telling her to do so. It wasn't long before she stopped crying and began to enjoy the trip, laughing with the roll of the boat and the water splashing. When we finally pulled back in to the dock, she didn't even want to leave the boat.

It is not too surprising for a little girl to be afraid of her first time in a boat on the water, on a windy day with water splashing all around, but given that she was forced to remain there, the worst that could happen was that her high level of fear would continue. Because we were somewhat successful in drawing her attention to

the more positive elements of her environment, she also responded with more positive (or at least neutral) feelings, forgetting her fears. This established a positive cycle—the more attention to positive things, the more positive feelings and the less fear. (You may have noted here that our attempt to focus her attention on the positive elements of her new environment was an application of centering.)

Although there is not much actual experimentation with direct confrontations with the feared object, a related technique (*implosive therapy*) has shown promising results (57): Prebyn is asked to vividly imagine and describe a feared object as elaborately as possible. In this imaginary situation, he encounters the aversive stimulus repeatedly without any negative reinforcement from that stimulus itself. In addition to the reasons already mentioned, there is another explanation for the success of forced exposure or implosive therapy: the repeated practice of one's own distress in a harmless situation becomes negatively reinforcing and is thus discontinued—the subject ceases to be afraid.

### Desensitization

Another important class of procedures included within reciprocal inhibition is referred to as desensitization (48, 65). It too makes use of relaxation and sometimes hypnosis to counteract unrealistic anxiety reactions. In desensitization, Prebyn is hypnotized or trained to relax completely and then asked to imagine some item low on a list of items which are anxiety inducing for him. Relaxation inhibits the weak level of anxiety which would normally result and he begins to respond without fear to that item. During the next step of the procedure, Prebyn moves to the second item on the list which elicits a bit more fear or anxiety. Once again the fear response is inhibited. Prebyn gradually proceeds through the list to items which would ordinarily produce more and more anxiety. During later stages he moves on to confront the real objects associated with his phobia.

Let's say that a cat phobic lists touching and handling cats as the most distressing, seeing a cat through a window (across the street or in a cage) as an intermediate fear, and seeing pictures of cats as distasteful but not actually frightening. We would begin desensitization by encouraging him to relax and think about cats, then progress to looking at pictures of them, reading about them, etc. Next he could spend some time watching cats in enclosed areas and not

within his reach. During the final stages the client could be induced to watch others play with a cat in the same room, and finally begin to approach and handle a cat himself. Throughout the process there is a gradual build-up of parts in the total experience associated with the phobic object. At every stage of practice the emphasis is on relaxation and minimization of anxiety. In fact, if at any stage the individual experiences anxiety or fear, it is an indication that the process is progressing too rapidly and the steps are discontinued, in which case one would return to a lower step and devise intermediate steps.

Let us take another example, the case of a man who complains that he cannot drive on freeways. We would first ask him to tell us everything about driving on freeways that he finds fearful, and then have him rank all of these relative to one another, from the most to the least distressing. His fears could include other people driving too close, missing the appropriate exit ramp, being cut off suddenly by another car, having the car in front stop suddenly, having a blow-out at high speeds, running out of gas with no place to stop, being involved in a chain-reaction accident, or skidding on wet pavement during rain.

Each item on such a list is a stimulus which elicits fear and anxiety, although they may differ in the extent to which they do so. To help this man produce a novel response to each of those items, situations are needed in which it is very difficult for fear to occur in response to any item. First he must relax completely. Then he is asked to imagine the least distressing item. Being relaxed inhibits anxiety, and therefore it is possible to learn a new response to that item. If the man is able to relax successfully without any sign of distress in response to this first item, we move up the scale to the next one, something about freeways which frightens him slightly more than did the first item. If this in turn is successful, we try the third item, and so on. This procedure may take one or two months, since the steps are graded very finely from least to most feared items, and success is achieved at each step before progressing. If, as does occasionally happen, the patient becomes quite anxious in response to any one of these situations, it means, as we mentioned above, that we have not graded the situations finely enough. It will then be necessary to find some intermediate situation—between the one which aroused the fear and the last one which was mastered successfully.

Audio-visual aids, such as movies and sound effects which increasingly simulate the feared situation, can also be helpful. The freeway phobic might, at some stage during his desensitization, be shown freeway driving in movies which simulate the view of the driver (as in drivers' training films). This technique might be especially good if he is terrified of rapidly moving vehicles.

Additional steps might involve having the man actually confront the freeway situation in a relaxed state. A situation could be devised in which the chances of risk are minimal and the actual confrontation is also minimal. Accompanied by a good driver whom he trusts, the patient might merely drive from one entrance ramp to the next exit ramp, very early in the morning or late at night when there is little traffic. This design provides the reassurance of a competent companion and maximally safe driving conditions. If the patient can accomplish this feat, he can drive again under similar circumstances but for a longer distance, then with more and more traffic, and so forth.

As the phobic attempts each of these steps, a new reaction is being learned to the act of driving on the freeway. He is learning to be relaxed, not afraid. Although the conditions under which he begins are safe compared to rush hour traffic, the fact of stimulus generalization remains, so that we can expect him to be able to relax more and more in freeway conditions which involve increasing degrees of danger, provided we continue to move him slowly from step to step.

### Rehearsal

Some of the techniques already discussed suggest that learning the skills for dealing with a critical situation can be facilitated by practice under similar circumstances which do not evoke as much negative feeling as the critical situation. There is a wealth of experimental evidence on this subject, and it suggests that learning transfers most readily to those tasks which most resemble the original learning task. This general finding is practiced quite intuitively and is by no means an extraordinary conclusion—its implications appear in our culture in various rules of thumb. Training situations for dangerous types of work or sports (parachuting, ski-jumping, air emergency procedures for a stewardess), are devised in such a way that they are analogous to the actual one, but exclude most of the dangerous elements. Military maneuvers, as part of the preparation for the battlefield, illus-

trate the extreme to which people simulate real and critical situations. Dress rehearsals for plays or concerts are held for essentially the same reason. Some individuals might even rehearse an important job interview with a friend prior to the encounter.

Let us briefly consider the process of rehearsal in terms of conditioning. In essence, it is the learning of responses to noncritical stimuli which gradually resemble the critical stimuli that elicit strong negative emotional reactions. Fear reactions interfere with learning because they cause certain responses which inhibit correct performance and minimize the occurrence of novel responses in the situation. Minimizing fear increases the possibility that new responses can be learned in the situation. Then the learning can be generalized gradually to other stimuli which increasingly resemble the highly emotional one.

Thus, even when a rehearsal situation is relatively artificial, if it resembles in some important respects the more critical and difficult problem, one's success might be sufficiently positively reinforcing to encourage him to exert further effort at successive stages. However, we also need to keep in mind that since the sense of mastery at each stage is an important positive reinforcer, the successive rehearsal stages should be difficult enough so that a sense of mastery is attained following each stage. This means that too many detailed and very similar rehearsal situations must be avoided. Let us consider a few everyday problems where rehearsal can be helpful.

*Moot: Many times when I attempt to express myself, I have to stop and form the verbal expression of what I am thinking. This often results in my inability to say anything for several long seconds, which is quite embarrassing.*

Rehearsal for Moot would involve situations varying along two dimensions: (1) gradual decrease of planning what he is going to say, and (2) gradual increase of listeners, particularly those who may evaluate him critically. First, while alone, Moot could read a certain amount of text and recite it aloud. This situation would involve no listener and he would already have the ideas he wished to express. The next step could involve a similar procedure, but would include a friend (a nonevaluative and nonthreatening person) to listen to his recitation. At subsequent stages he would restrict his speaking at social gatherings to more structured materials such as stories or jokes.

Meanwhile, when by himself he could use a tape recorder to practice talking spontaneously. During the final stages of rehearsal, he might talk spontaneously to close friends in preparation for spontaneous conversations with strangers or evaluative persons.

In citing Moot's example, we had to present the progressive steps arbitrarily. In an actual case of rehearsal, Moot himself would assist by deciding how large a step he felt would be feasible at each point to bring him closer to his goal.

*Kritt: Since I live away from home, my parents do not know all that I do and think. I know they would be disappointed if they did. I can appreciate the role of the parent as a guide for me, even though I am 21 years old, yet I want to be an individual who can make his own mistakes and take the consequences. Thus, when I am with my parents I feel that I am acting hypocritically by attempting to please them and acting like they think I should.*

Breakdowns in communication are not infrequent when a teenage son or daughter leaves home to go to college or to work. It is generally a period of accelerated development during which the young adult undergoes a considerable change in his identity, his values, and his view of his family. He often experiences discrepancies between his new attitudes and those of his parents, and he may feel that the gap is almost irreconcilable.

Kritt feels that he has only two alternatives: to act "hyprocritically" vis-a-vis his parents by behaving as he knows they would like him to, or to overwhelm them suddenly with his new attitudes, which are contrary to theirs. Both alternatives being unacceptable, a graduated transition may again be most appropriate. It would have a two-edged effect. It would provide a method for Kritt to begin very gradually to change his behaviors vis-a-vis his parents, first communicating certain attitudes which are novel but fairly palatable for them, then moving on to more discrepant attitudes, which are possibly less acceptable. At the same time, it would serve to expose the parents gradually to Kritt's new identity, allowing them sufficient time to adapt to the new changes they discover.

Specifically, Kritt could list all those changes in himself and his attitudes which he felt he was hypocritically concealing from his parents, ordering them from those most likely to be acceptable to those which would most upset them. He would then seek an oppor-

tunity to communicate the first item on the list to his parents, being willing to discuss it at length with them if the occasion arose. He would gradually proceed with the more difficult items as opportunities presented themselves.

It is possible that at some stage Kritt would arouse dismay, anger, or resentment in his parents. The occurrence of such a negative reaction would suggest a return to the level which had been successfully attained. When it seemed appropriate to move on once more, Kritt could use some intermediate steps before again mentioning the issue which brought forth the negative reaction.

Although this might seem an inordinately lengthy process, it would allow the parents to learn Kritt's new attitudes and way of life, and adapt to these changes without sudden shock or dismay. And as time passed, Kritt would feel more honest and comfortable with his parents, and therefore be better able to deal with the more difficult steps on his list.

Kritt's kind of problem can also occur among peers.

*Mabel: I have a problem deciding whether to be myself or to role-play. That is, to be what I think the person I am with expects or wants me to be. This applies especially in a dating situation when I think highly of the other person and yet do not know him well. Most of my life there have been a few people whom I have known over a period of years. It seems as if adjustment to a new set of people must involve adaptation, but how far can I go and still be "myself"?*

Again, Mabel might list those aspects of her identity which she wishes to maintain in any relationship but which she has difficulty in consistently communicating to people she meets. She would start with the easiest item on her list and try to communicate it consistently to new acquaintances. Having mastered this first step, she would proceed to the other, more difficult items on her list.

Mabel's approach would combine the principles of rehearsal with those of defining expectations. As Mabel communicated certain things about herself consistently in different relationships she would in effect be defining these qualities as part of the role others could expect of her. As we have already seen, it is easier to maintain expectations which are communicated at the initiation of a relationship than to change already existing but undesirable ones.

## SUMMARY

The first concept introduced in this chapter was that every re-
sponse is determined by a given stimulus or situation, and that the
control of the situation can thus provide control over the behaviors
which occur in it. A second aspect of stimulus-response relationships
is that the presentation of a stimulus which at first does not elicit a
response, followed regularly by an unconditioned stimulus which
does produce that response, eventually causes the first stimulus alone
to elicit the response. This basic idea of conditioning explains a large
number of emotional reactions and constitutes a basis for reciprocal
inhibition.

Reciprocal inhibition is a powerful technique that is applied to
overcome anxiety that has been inadvertently conditioned to certain
stimuli, such as phobic reactions (fear of heights, animals, or certain
activities). In applying the method, Prebyn is induced to engage in
some activity, such as eating or relaxation, which counteracts his
anxiety reaction at the physiological level. While doing so, he faces
the feared object—or, at first, some object which resembles the
feared one, gradually increasing his exposure to the feared object
until he can face it without fear.

The related technique, rehearsal, is based on the premise that it
is easier to transfer knowledge or skills from one area to another
similar area than to a dissimilar one. Therefore, solution of a problem
is best achieved by starting with a similar, but easier, task, and then
proceeding to more difficult steps gradually. By learning to function
successfully during the easier stages of rehearsal, one can be confi-
dent and relaxed since the threat of failure or danger is minimal. This
relaxation generalizes to the next, more difficult step, making it in
turn easier to overcome, and so on, until one finally learns to function
with relative ease in a situation which originally provoked anxiety.

In closing we need to briefly compare the four techniques of re-
ciprocal inhibition, desensitization, forced exposure, and rehearsal,
to consider the conditions under which each might be most appro-
priate. Rehearsal is readily distinguished from the others because it
is used to counteract realistic fears or dangers, whereas the other
three are used with more unrealistic fears or anxieties.

Among the other three, forced exposure or implosive therapy
would seem to require a very trusting relationship between Prebyn

and Ragent. It can best be used when fear is moderate, with reciprocal inhibition and particularly desensitization being used for the extremes.

Desensitization is a special case of reciprocal inhibition which relies on relaxation to counteract anxiety. The other means of inhibition discussed—eating, strenuous physical activity, self-assertion, or a high level of sexual excitement—have more limited application and can be used only in special circumstances. For instance, it would be somewhat impractical to use eating to inhibit one person's fears in a vast number of situations. Thus, another rule of thumb could be to use desensitization techniques, rather than some of the other inhibitors, for severe and more pervasive problems (66). So, when a person expresses difficulties or is anxious in his relationships with relatives, friends, and at work, desensitization might be the appropriate technique. If, in contrast, he simply has a fear of heights or some specific class of objects, some of the other inhibitors may be easier to use and provide a quick resolution to the problem.

Finally, for less severe problems, reciprocal inhibition can be readily used by psychologically untrained persons, whereas desensitization is more elaborate and time-consuming and requires greater familiarity with relaxation techniques. Thus, a mother whose child is afraid of the dark might herself think of a way to counteract his fear, but she might have more difficulty applying desensitization if the child refused ever to be left alone.

SIX

# *A TIME*
# *AND*
# *A PLACE*

Now that we have discussed the definition of problems and some of the techniques that can be used to change a specifically defined behavior, we need to know *when* to put the techniques to work. Part of the general know-how of behavior modification is the ability to recognize when conditions are "ripe" for influence. So now we'll attempt to establish the conditions under which a behavior is most likely to be changed successfully and, further, see how such conditions can be deliberately brought about to make an individual more open to the change that is desired (41).

## INADEQUACY

We have already noted in the discussion of modeling that a person is ideally susceptible to influence when he enters a new situation, an unfamiliar, ambiguous one for which he has no well-

defined repertoire of coping behaviors. A college freshman when he first arrives on campus, an adult on his first day at a new job, a child who enters kindergarten, a housewife who first meets her new neighbors—all exemplify persons when they are particularly apt to model others or be open to suggestions about how to behave, feel, or think.

A more general rule of thumb is very simply that Prebyn is expected to be susceptible to influence when the positive reinforcers in any particular situation begin to diminish or the negative reinforcers begin to increase. Of course this doesn't mean short-term, day-to-day fluctuations in the "net" (total positive minus total negative) reinforcement level, but rather relatively permanent changes over an extended period of time. When this happens Prebyn experiences what we will refer to as a state of inadequacy.

Typical examples of inadequacy are seen in children whose previous level of skill ceases to be sufficient as they approach each new stage of development (infancy, preschool, or grammar school). For instance, a child first learns to get around by crawling, and receives many positive social reinforcers from parents and other adults for doing so. But as he approaches twelve months of age, his parents begin to expect him to walk and no longer exhibit much pleasure when he crawls (they decrease their reinforcement of crawling). So if he is to regain those reinforcers, he must learn the new skill of walking.

Adolescents also experience inadequacy when they begin to face "grown-up" social situations, or when they move from high school to college and find discontinuity in the level of scholastic and social skills which are required in the new setting. Inadequacy in adults may perhaps occur when changes in production techniques within industry render a worker's skills obsolete. Skills which were a crucial source of positive reinforcement from the environment (job, income, security) cease to fill the individual's needs and thus are no longer reinforcing.

It should be emphasized that inadequacy is situation-specific, such that one person may feel inadequate in certain situations but not in others. It is the behaviors associated with those situations where inadequacy occurs which are most susceptible to influence.

Let us return to the child who was nearing the age of twelve months to see how social influence is instrumental in reducing inadequacy. The child may not be aware of the reason for the decrease in positive reinforcers from his parents, and in the absence of explicit guidance or prompting by the parents, it is unlikely that he will be

able to comprehend or cope with this sudden change. However, most often when the gratifications are diminished due to parents' higher levels of expectation the parents also present models and salient prompts to help initiate the learning of the newly required skills. In the case of the shift from crawling to walking, the child may be held up by his arms and reinforced for trying to walk. Consequently the inadequacy does not persist because the child quickly learns that his attempts at walking can be a new source of reinforcement. Of course, this type of inadequacy is a regular part of the growth and learning process, and such learning is frequently intuitive rather than conceptual. That is, although the child may sense the positive or desirable consequences of his attempts to walk, he may not conceptually relate walking to pleasurable consequences.

In general, then, one can reduce a moderate state of inadequacy if (1) there are models in the environment whose positively reinforced behaviors are observed and emulated by the learner, (2) there are individuals or other sources (books) which conceptually transmit specific information or general guidelines about what behaviors can be reinforcing, or (3) if there are environmental prompts which guide the learner's trial-and-error behavior in that situation. In all instances, it is seen that inadequacy breeds susceptibility to influence: while feeling inadequate, an individual becomes acutely aware of and willing to accept models, environmental prompts, or suggestions.

As they prepare to approach a novel situation, some people anticipate this possible inadequacy. Thus, if Prebyn decides to pursue a sport such as skiing, tennis, or sports car racing, he knows that, at least temporarily, he will feel awkward and possibly embarrassed, be subordinate to others, and probably not even gain too much satisfaction from his efforts. So he may turn to books or other people to obtain some general guidelines and learn what to expect and how to behave. Alternately, he may take the more concrete approach of watching the skill performed and then copy or model it; or he may even secure a guide or instructor who observes him, prompts him to certain actions, and then reinforces him as the actions are more correctly produced.

### Extreme Inadequacy and Psychopathology

As already mentioned, the inadequacies discussed above come about as a normal part of learning and development and are usually

resolved without undue distress. But if inadequacy occurs and no effective guidelines are available from the environment to help Prebyn overcome it, he is then forced to resort to haphazard trial-and-error attempts. Such attempts lack stability, because Prebyn flounders along, randomly seeking solutions but having no system for structuring his activities, no means toward the end. The most dramatic illustrations of this are seen in panic reactions, whether individual or mass. Imagine losing your child at a huge parade, being imprisoned (spy-style) in a dungeon whose walls are closing in, or facing some impending disaster. Classic examples of mass hysteria are the stock market crash of 1929 and Orson Welles' infamous "War of the Worlds" broadcast in 1938 in which people across the nation interpreted his dramatization as a genuine news flash and were led to believe that Martians were invading the earth at that very moment (22). In both instances, there was no way to avoid the catastrophic consequences and no known means for coping with such sudden and massive changes in lives and futures. Both events produced all varieties of haphazard reactions, including suicide.

There is another reason a person might sometimes resort to this trial-and-error means for overcoming inadequacy. When Prebyn is learning a new skill, he must rely on other skills which he already possesses. To learn to take notes during a lecture, he must know the language being used, be able to write it quickly and automatically, and also be able mentally to select and organize somewhat automatically, so that he can be fairly free to concentrate on what he hears. When Prebyn lacks any one necessary skill for coping with a new learning situation, he is more likely to "fall apart," to panic slightly and attempt trial-and-error methods to cope with the situation. It is seen, then, that sudden, extreme, and unrealistic demands for a change can induce a high degree of inadequacy because a person's skills are simply not commensurate with those demands and cannot help him reverse the trend of diminishing reinforcement.

Naturally, inadequacy brings along with it frustration, helplessness, and possibly anxiety. These negative feelings can generate internal distraction, which further interferes with problem solving attempts. So if such a condition persists, a vicious circle ensues—random and mutually contradictory activities, increasing negative feeling, increasing distraction, decreasing ability to cope with a situation, then greater inadequacy. Very simply, one is less likely to be able to solve a new kind of problem if he is anxious and uncomfortable than if he

is relaxed and undistracted. Further, this is likely to be the case if environmental demands are unrealistic.

Trial and error seems to be prevalent in extreme cases of pathological disturbance, where an individual is very anxious and helpless in certain interpersonal situations. He may have resorted to this primitive method of coping due to a continued state of inadequacy or a sudden and unrealistic increase in demands from his social environment at some stage in his development.

If trial and error doesn't work, then as a last resort the person may try to avoid the troublesome situation. If that isn't possible either, he may simply busy himself with useless, compulsive, and ritualistic behaviors while in the situation—a phenomenon that can be understood in terms of reciprocal inhibition. If a repetitious activity is very strenuous in nature it may inhibit anxiety and fear, or if it involves a low level of physical exertion it may, due to its monotony, induce relaxation which in turn would inhibit the anxiety. This way the person can at least escape the anxiety caused by his problem, even though he cannot cope with the increased negative reinforcement.

Avoidance as a solution is exemplified by phobia. A phobic, as has already been noted, avoids his feared object rather than seeking new ways to cope with it. Similarly, when a person experiences inadequacy in a certain situation and does not acquire any new skills to cope with it, his behaviors in response to that situation eventually are more likely to become rigid. This is because although there was an initial decrease in the net level of reinforcers, with the passage of time the decrease stops and there is a new, lower but stable plateau of reinforcements which eventually can be adapted to. With such adaptation, there is less immediate and painful inadequacy, since inadequacy is most acute when reinforcers are diminishing.

What this all means is that when a person has a problem of long standing, chances are that he will be less susceptible to influence. The person who has only recently encountered inadequacy experiences greater pain and is therefore readily amenable to suggestion. But changing a person with a problem that has persisted for years requires more elaborate techniques—one first needs to break down and disorganize the rigid modes of functioning the person has adapted to before proceeding to teach him new ways. This, incidentally, is one of the reasons it is important to detect the onset of psychological maladjustment early.

## Inadequacy Through Satiation

Inadequacy can be generated by internal changes—satiation—as well as by changes in the environment. Although the level of reinforcement from a situation may remain constant, satiation may cause one subjectively to experience a decrease in reinforcers. Since the effect of satiation can be cumulative (repeated use making a reinforcer less and less valued), the inadequacy brought about by this process can cause persistent susceptibility to influence. It is a pattern that accounts for shifting interests, avoidance of routine, exploration of new hobbies, sports, and friends.

These ideas have some implications for long lasting, intimate relationships, such as marriage. Any entity which is a varied source of reinforcers is less resistant to satiation than another which was highly reinforcing at first but did not change. Some marriage partners, for instance, who continue to develop their interests and avoid "ruts" will probably continue to be reinforcing to one another; others who do not grow or change over the years may find their reinforcing quality for each other subject to satiation. The resulting inadequacy, if it is not resolved, could lead to a disruption of the relationship.

## HOW TO INDUCE INADEQUACY

Our discussion has suggested that inadequacy is one of the significant aspects of growth and change, and further that one is most susceptible to influence when he is experiencing inadequacy. It follows, then, that when a person behaves in a rigid and repetitious way which is undesirable, he can be made more susceptible to influence if he can be made to feel inadequate. Thus, it is necessary to find techniques which will suddenly make his stereotyped, rigid ways of behaving even more negatively reinforcing for him.

Some of the techniques of group therapy make use of inadequacy as a vehicle for hastening change. In one method, one person in a group becomes the target of open criticism by the rest of the participants. During this period when he is completely exposed to critical examination, most of his socially objectionable behaviors, as well as his usual methods of warding off criticism, are exposed and attacked by the rest of the group members. All of his existing skills cease to function adequately because any of his counter-attacks, justifications, or rationalizations are quickly disqualified and rejected by the others.

The process is a grueling one. It induces a high state of inadequacy by essentially stripping a person of his habitual means for either overlooking his own deficiencies or reinterpreting them in ways that are acceptable to himself and others. In short, his habitual ways are of little help to him in avoiding the negative reinforcement from the group.

Of course, the group also provides a variety of models, both verbalized and implicit, which the target individual may consider as possible alternatives to his habitual behaviors. And the high inadequacy may induce him to try some of these novel behaviors which he might not have considered otherwise. The therapy also proceeds in such a way that the same individual is not always the target of criticism—sooner or later each member of the group becomes a target.

A word of caution: This method can be beneficial for a carefully supervised group in which most of the participants have considerable psychological strengths to depend upon during the group encounter, but it can also be extremely destructive for an individual who is generally maladjusted and unable to make constructive use of the criticisms. As we have already seen, inadequacy of a high degree can lead to crisis and deterioration when Prebyn is requested to make changes that are far beyond his reach. This is what would be happening if a severely disturbed person were to undergo such a group experience, and serves to underscore the importance of having professional group leaders (54).

As in the case of group therapy, individual therapy techniques have sometimes drawn upon the induction of inadequacy to make the patient more susceptible to influence. For example, Ivar Lovaas developed a technique to help some autistic children overcome their consistent avoidance of people. Autistic children are extremely slow in their intellectual and social development and highly unresponsive to people, thus it is difficult to help them learn language or other social and intellectual skills. Making them responsive is an essential therapeutic step.

To accomplish this, Lovaas and his colleagues induced inadequacy and combined it with shaping as follows (35). The experimental room was constructed so that a small electric current could be administered to someone standing barefoot on the floor. When the barefoot child and the experimenter were placed in the room, the current was turned on. No matter where he went in the room, the child felt the

slight pain due to the current, *except* if he approached the experimenter, in which case the shock was turned off. When he moved away the shock was turned on again. Thus his approach toward the experimenter was shaped, since he learned very quickly that approaching the experimenter was positively reinforcing. Two major goals were accomplished simultaneously: the child's rigid avoidance of people was disrupted by inducing inadequacy, and another person was there to help him find a way to cope with this inadequacy, which in turn made at least one person a source of positive reinforcement to the child. In this way, bodily contact with the experimenter or other persons became reinforcing to the child and could therefore be used in his training.

Another technique for counteracting rigid behavior involves the use of paradoxes. Paradoxes can be used to change rigid behavior that is extremely pathological or simply to change undesirable but habitual ways of doing things.

The technique of introducing imbalance into conventional patterns of thought has been traditionally used by Zen masters to help enlighten their students. Zen training involves the juxtaposition of seemingly contradictory and irreconcilable ideas or paradoxes in order to break down narrow and false conceptions of the world. These paradoxes may occur in the form of the *koans* or impossible questions. For example, in response to a student's question regarding some abstract issue a Zen master might respond, "If you don't know the answer to that now, then you are not ready for the answer and my telling you won't help." The paradox may also occur in the personal confrontation between master and student. In one situation, the master holds a stick over the student's head and tells him that he will hit him if he says the stick is real; if he says it is not real, then he will also hit him since it couldn't hurt. What is the student to do? His master has encouraged him to continue in his past ways of conceptualizing reality by presenting the traditional idea that (1) objects are either real or not real and (2) students must obey masters. At the same time the master has made it painful for him to continue to rely on this sort of conceptual system. The only way out of such a bind is for the student to change his way of classifying objects, that is, to relinquish the alternatives "real" and "not real"; or he must relinquish his idea about his relationship to the master. He might do the latter by seizing the stick from his master.

Experiments have dealt with more common paradoxical situations

which induce imbalance in a person's way of thinking. Suppose one finds that person A, whom he likes, is fond of person B, whom he dislikes. This is a common form of imbalance, especially in those cases where the implicit assumption is that a person's friends should like and dislike the same things he does. Operating under that premise, such imbalance is negatively reinforcing, leads to inadequacy, and may eventually necessitate a more differentiated view of B, or other disliked persons in general. Thus one consequence of imbalance may be a willingness to accept the idea that, although there are many aspects of a liked person's values and preferences that one shares, it is not necessary to share them all. This kind of differentiation is a more complex and realistic way of viewing others.

Because of the imbalance which they create, paradoxes sometimes cause a breakdown of a certain way of thinking, thus making a person more amenable to influence and new or more differentiated ideas and actions. You might try to see how the technique could be used to induce change in the following situation.

*My wife is a Negro. I find it frustrating that after four years her relatives and friends still class me as either snobbish or "poor white trash." Like the white man, Negroes have learned to classify everything as either-or: permissiveness indicates white-trash background; firmness indicates bigotry. I usually choose firmness, and this in turn makes my wife an automatic "Uncle Tom" in their eyes.*

One approach might be for the husband to find out exactly what "bigotry" and its opposite mean to the relatives. Once he knows what behaviors definitely do not indicate bigotry, he could focus carefully on those aspects in himself when he visits with his wife's relatives, making them particularly salient. In other words, the entire approach would be based on systematic induction of imbalance, by combining two qualities which, in the relatives' definitions, cannot possibly occur together, such as firmness with distinctly nonbigoted behaviors. In this way it would be difficult for the relatives to continue to view firmness and bigotry as a strictly one-to-one proposition.

The temporary induction of imbalance and paradoxes may also be a legitimate tool to aid in redefining rigid and unsatisfactory relationships between people. For example, between a parent and child, an older and younger sibling, or a married couple, one member may

doubt the integrity of the other and treat him as though he were unable to make decisions for himself or act responsibly.

*Lorna: I am staying with my older brother and sister-in-law. My problem is that Dune, my brother, is not able to understand me. He still doesn't seem to realize that I am grown-up, mature, and know a little bit about the world. If I am left alone, I can do things my own way and they will come out OK, but he is not ready to accept this fact. He still treats me as a child. I don't resent giving him the respect due an older brother, but at the same time I just don't like to be treated like a kid.*

It may be possible to resolve a dilemma like Lorna's by temporarily inducing inadequacy in Dune—designing a situation which is relatively unfamiliar to him but in which Lorna is relatively competent. When Dune must then turn to Lorna for guidance or assistance, he must implicitly recognize her expertise and responsibility and give due credit for her level of attainment. Perhaps Lorna could engage Dune in some sport, hobby, or intellectual pursuit (history of Impressionism, political development in South America, etc.) at which she excels, and which he might enjoy but is unfamiliar with. If a series of situations can be devised in this way, over a period of time it would be dissonant for Dune to continue to view Lorna as an irresponsible child.

The autistic children in Ivar Lovaas' experiment and the student of the Zen master are in many respects captive audiences of someone who has considerable power over them. Unlike them, most of us who will ever need to deal with a rigid individual would need to be more subtle, using techniques similar to the one suggested for Lorna. Most psychotherapists, for example, do not have the power to punish a patient for rigid behavior, so they must rely on more subtle techniques.

Rosen, who worked with schizophrenics, created situations in which the client's way of thinking became a source of distress (53). He began by accepting a patient's belief about some issue and talking to him about it on his terms. But while doing that he attempted to introduce circumstances in which the patient's system was ineffective, self-contradictory, or without clear-cut implications for action. Thus, without overtly rejecting the system, Rosen made the schizophrenic's ideas dissonant and distressing for him. One of his patients had been using fantasy to escape a painful situation—her fearful and

negative feelings toward her father. She believed that he had been condemned to death and was awaiting execution in the state capital. Rosen gathered members of her family together (whom he had drilled ahead of time). They produced a "reprieve" from the governor and then celebrated the occasion together with the patient. She was dazed by the whole affair and participated in the celebration stiffly. She had been forced to accept that her father was really not going to be "out of the way." Once her delusion had been interrupted and she was forced to face the reality of her fear and guilt, there was a better chance to resolve her psychosis.

When a person is repeatedly left in confusion over his own ideas, as Rosen's patient was, particularly in some area which is crucial, there will be at least a temporary disorganization of that conceptual system. And if, at that point, the environment provides an alternate way of thinking about things, it may be included or incorporated into the conceptual system, thus making it more realistic.

Lindner illustrates yet another approach: initially accepting a patient's delusionary and rigid way of thinking, and then elaborating upon it in various ways to make it less reinforcing for the patient (34). In the case he presented, the patient had certain ideas about having contact with another solar system, and Lindner encouraged him to discuss these ideas during therapy. When the patient presented details of these ideas, Lindner began suggesting additions and corrections here and there, becoming really enthusiastic. He began to take the initiative in talking about the system and the contact with it. The more Lindner became involved and the more he suggested changes, the less initiative the patient took in discussing his delusionary system, until finally he gave it up entirely. Lindner's technique made the patient's particular delusion less positively reinforcing for him, since it was taken out of the patient's control and was no longer his own special creation or preoccupation. As in the case of Rosen's patient who had been constantly preoccupied with the idea that her father was condemned to death, here too the effectiveness of the method was that it eliminated a persistent and time-consuming behavior and made room for more constructive therapeutic activities.

Let us consider one last technique for breaking down rigid modes of behavior. Sometimes we find ourselves dealing with a person who, in a very stereotyped manner, insists on assuming a certain role in relation to us. Despite our complaints and unwillingness to be party to such a role relationship, we find ourselves unable to alter the situ-

ation. In these instances, occasionally it is possible to restructure the situation by assuming a role which, in terms of the specific behaviors involved, is quite similar to the role the other person has assigned to us, but in terms of its psychological significance is dramatically different from what the other would wish it to be. The following case may help clarify.

*Martha: My roommate is self-supporting and fairly mature. Her mother did not give her enough attention when she was younger and often it seems that she is somehow trying to make up for this past loss by meddling in my business and acting motherly toward me. Sometimes she goes around picking up after me. Although I am messy now and then, it irritates me to have someone constantly straightening up behind me.*

Assuming that the statement is correct as it stands and that the roommate does behave in a motherly way toward Martha, the following approach may be effective. If Martha can anticipate the roommate's mothering by noticing when she is about to start picking up after her, she can assume a manner which suggests that she herself, rather than the roommate, is in control of what transpires. A request such as, "Could you please help me pick up some of these things?" will dramatically change the significance of the roommate's picking up after Martha. Such actions previously signified her role as a responsible adult or mother-like figure vis-a-vis a careless child. But picking up at Martha's request transforms their interaction into an adult-adult relationship. Since picking up things then ceases to symbolize the mother-child relationship, which the roommate wants and which is somehow reinforcing for her, it is very likely that she will stop. Of course, it is also possible that she may then continue her attempts to establish a mother-child relationship in other ways. In that case, similar restructuring techniques can be employed. Following several of these attempts, the roommate will begin to treat Martha more like an adult than a child.

## SITUATIONS THAT MAKE PEOPLE INADEQUATE

We have already seen that one person does not feel inadequate in all situations, nor do different people feel equally inadequate in the same situation. Rather, inadequacy is a combined function of a certain person's characteristics and a certain situation. Nevertheless,

situations do differ in the degree of inadequacy which they generally elicit, and it is possible that one unfamiliar situation where mistakes can be embarrassing (having an audience with the Pope) will induce general inadequacy (more in some people than in others). Another type of unfamiliar situation (shopping in a new grocery store) does not elicit inadequacy except in an occasional person.

Variations in this inadequacy-inducing quality can be determined as follows. Situations that are more likely to induce inadequacy are (1) those that are ambiguous or (2) those where the consequences of some kinds of behavior can be extremely punishing. If a situation has both qualities, it is especially likely to induce inadequacy.

An ambiguous situation is one in which it is extremely difficult to infer what the positive and negative reinforcing consequences of any behavior might be. Thus, one has trouble deciding whether to act one way, another way, or not to act at all, since no choice guarantees the avoidance of negative reinforcement.

Suppose you are to meet an important out-of-town executive for your company, and it is your implied responsibility to provide him an enjoyable stay in your city. You are strangers, and he turns out to be the rather silent, unapproachable type. The resulting situation is ambiguous because you don't know what to suggest, what he likes, what he's thinking, or what the consequences for your company will be, so in anticipating possible failure on your assignment you feel somewhat inadequate.

Thus, situations can also be ambiguous when one is unsure how to react, when the circumstances are unfamiliar, when no explicit rules of conduct exist, or when there is a lack of information about guidelines which do exist. In a grocery store there are a limited number of behaviors possible and a minimum of ambiguity; most people know what to expect there, how to understand the situation, and how to behave in it. And relationships with familiar people are less ambiguous because one knows what to expect and how to act with them. In some relationships, however, ambiguity may persist beyond the getting-acquainted stage because one of the participants is less willing or able to communicate his preferences, or he is inconsistent, evaluating certain actions of the other positively at one time and negatively at another. Also, relationships with people who are complex (in that they have an elaborate set of behaviors, expectations, and evaluations) may remain ambiguous for relatively longer periods of time. Thus, the extent to which a person is an ambiguous

stimulus for others varies in terms of his complexity, his inconsistency or confused functioning, and how much he withholds information about himself.

The following problem illustrates characteristic inadequacy due to the novelty or ambiguity of situations.

*Lillian: I find myself most uncomfortable in any situation in which there is anything new, whether it be the physical environment or the people. This is so not only in relatively big changes, such as starting a new school or beginning a new job, but in everyday situations as well, such as going into a market, shop, or restaurant which is new to me. To be comfortable in a situation, I have to be familiar with it. As a result I revolve my life only around the most familiar things, and that keeps me from discovering new interests and experiencing all facets of life.*

Lillian has a severe problem due to its extreme generality. But it could be partially counteracted if, before entering any new situation, she would seek a model whom she trusts and who is familiar with that situation. Being accompanied by such a model should lower her level of anxiety and allow her to learn some of the skills required for coping with the situation. She could do so in a series of graduated steps: she might first try those new situations which are most appealing to her (a new restaurant, theater, shop, etc.) and gradually move on to more difficult settings. At each stage of this series, however, she would need a companion who is capable of coping with various facets of the new situation and from whom she can learn through observation.

In an ambiguous situation, the possibility of strong punishment (extreme danger or risk) following one's actions also contributes considerably to inadequacy. For two situations which are both moderately ambiguous, the one in which mistakes can be more damaging induces more inadequacy because the anticipated decrease in net reinforcement is greater. It follows that any situation which is highly ambiguous and in which mistakes can be very costly can in general induce inadequacy in most people.

### Use of Ambiguity for Power

Mr. Gross, vice-president of a brush company, has given Mr. Klein, one of the traveling salesmen, only vague ideas about his responsi-

bilities or required level of performance. When Klein requests spe-
cifics, Gross responds in essence with, "Do your best. Do whatever
you can." He does not apply pressure or push Klein to his maximum
level of capability; he simply indicates casually that Klein should do
the best he can at his own comfortable pace. Gross may nevertheless
subtly reinforce Klein when he produces a greater than usual amount
of work. In this way, while influencing his employee, Gross continues
to maintain the psychological advantage—Klein cannot complain that
his boss is too demanding.

Two principles are employed in combination here to gain a posi-
tion of advantage—the induction of ambiguity by minimizing the
amount of information given, plus the use of implicit reinforcers in
shaping. The explicit statement of desires is held to a minimum, and
those which are made are stated ambiguously enough that Klein is
still unclear about what is expected of him.

Creating ambiguity by withholding information is more than
familiar to power-oriented nations in their political dealings. For
instance, it is interesting to speculate about the withholding of
information and its function in diplomatic negotiations, such as in the
Vietnam peace talks. Throughout such negotiations, the representa-
tives of each side maintain secrecy about their intentions, thereby
inducing ambiguity, inadequacy, and susceptibility to influence in
the other side. As a consequence, the negotiation process is a pain-
fully slow movement of slight hints about small compromises in
return for corresponding concessions.

Incidentally, in contrast to the preceding, there are certain short-
range interactions in which the withholding of information may not
be an effective lever, since time is not available to use shaping
techniques. For example, in "one-time" bargaining (buying a house
or car) it has been found that it pays to make a realistic but very
firm statement of one's offer, indicating no compromise: "Either
accept my offer or forget the whole thing." Holding a firm position
seems to be more effective than starting from a high demand and
gradually reducing it, since the others quickly realize that they must
complete the transaction in these terms or enter another bargaining
situation. Therefore, they may be willing to settle for less than they
had wanted in order to save themselves further effort. If instead,
one begins by communicating a relatively high level of expectation
but indicates that he may be willing to settle for less, others will be

encouraged to push their luck further, to test the extent of compromise they can get.

Let us return to a final example of the systematic use of ambiguity as part of social influence. Ian Fleming described a technique which the Russian espionage agencies supposedly use with those whom they wish to influence (19). The technique involves the use of sucsive positive and negative reinforcers on a person without allowing him to know why he is being reinforced in a given way. An example of this would be an interview in which the interviewer is randomly helpful and considerate toward the interviewee at certain times and is hostile and threatening at other times. In this situation, since the changes in the interviewer's attitude are deliberately random, there is no way for the interviewee to know how to behave in order to minimize the possible threat. Again, in a cold war situation such a random mixture of positive and negative actions from one side to the other can be very confusing and frustrating for the receiver, particularly when the receiver is in a less powerful position to begin with.

How can we understand such a method? Why is it that a series of random positive and negative reinforcers are more effective in inducing inadequacy and therefore change than, say, shaping techniques which are contingent on Prebyn's behavior? Because Prebyn has no way of understanding why he receives positive or negative reinforcements at any given time. He does not always receive negative reinforcement nor always positive reinforcement, thus he cannot conceptualize the situation as either primarily hostile or primarily benevolent. Consequently he cannot determine how to react rationally to the situation. This type of ambiguity induces extreme susceptibility to influence, because Prebyn, experiencing acute inadequacy, will grasp eagerly at any kind of directive or "advice" which looks like it could provide a stable guideline for avoiding possible negative reinforcement.

Once this type of malleability is established, Ragent has assured himself of considerable compliance from Prebyn and can proceed to shape his behaviors. This is a familiar technique for "breaking" a subject, whether he is a prisoner of war, a member of the Cosa Nostra, or a character in a novel by Ian Fleming.

SEVEN

# *RECAPITULATION*

## TRANSITIONS FROM EASY TO DIFFICULT

In this final chapter we need to elaborate on the principle of
beginning with the behavior that is easiest to change and gradually
proceeding to the more difficult. This is particularly important
when complex problems are involved, in which several behaviors
require change. Indeed, even when only one behavior needs
to be changed, special analogues of it may be devised which are
simpler and serve as practice for the more difficult aspects
of the change that is required.

In general, whenever one is trying to learn something which is
novel and difficult, he may anticipate possible failure—no gain for
his efforts, pain, and loss of face or self-respect. Further, if he
has failed before when attempting to learn this new behavior, trying

138

it again may be associated with vague (or not so vague) feelings of distress and anxiety. Learning proceeds more slowly when there is a high degree of anxiety, so that the presence of strong negative feelings can be distracting and can diminish the possibility of success in changing behavior patterns. It follows that in learning new social skills, or attempting changes in others' behaviors, one would find it helpful to order hierarchically the various aspects of the required change. The changes listed at the bottom of the hierarchy would not only be easier (that is, associated with less negative feelings due to anticipated failure) but also, once accomplished, they would provide the person with skills he did not previously possess. The latter in turn would ease the difficulty of the progressively higher steps in the hierarchy.

A third reason to order changes in this way, again, is that when a person succeeds (when he is positively reinforced for his efforts) at one part of a task, he is more likely to continue and persist in trying another part. Starting with the easy parts of a problem helps to insure that a person's anticipation of positive reinforcement will exceed his expectation of negative reinforcement.

The whole idea of progressing from easier to more difficult steps may be summed up nicely with an African proverb: The best way to eat the elephant standing in your path is to cut him up in little pieces.

### Procrastination

*Procrastination, mainly with school work, is my biggest problem. I have an amazing ability to do everything else but that which has to be done. I can rationalize beautifully but realize that if I would just sit down and work then I wouldn't have this problem. It keeps me in a constant state of worry. It is a cyclic trap—the longer I put off something, the more I worry.*

Getting started can sometimes be the main problem, particularly when one faces a big, complex project which is going to require overwhelming amounts of time and effort. This is even more the case when the possibility of failure seems imminent.

According to the techniques we have outlined, the easiest way to outwit procrastination is to make a list of the various tasks a project involves, order them in terms of difficulty, and begin by tackling the first item on the list.

Such a procedure maximizes the possibility of success and, there-

fore, the positive reinforcement of our initial efforts. It also provides a plan for action which not only helps maintain motivation throughout but, most importantly, is effective in counteracting the initial inertia. That is, if someone has a complex problem to face and resolve, then he is more likely to initiate a solution to the problem if he has one easy part to complete first.

In a typical version of procrastination, a person's difficulty with one major problem inhibits his progress on one or more unrelated but easier tasks. His preoccupation with the major problem gives him an excuse for procrastinating immediate and day-to-day obstacles.

Let us say Prebyn is about to begin a large project at work, one upon which his advancement depends and which will require a considerable investment of time and effort. Meanwhile he is also preoccupied with a complex family problem which is keeping him in constant distress. While apparently thinking about his project and how to approach it, he finds excuses for postponing it, justifying them to himself because of the seriousness of the family distress. But his brooding over the family problem does not help solve that, either. He is thus caught in a stagnant state where delay becomes an additional source of distress, and where the negative feelings and frustrations associated with his project and the family problem each discourage constructive approaches to the other.

This pattern can be understood as follows: First there is hesitation because he does not know how to start his project. He may not even have considered it in terms of parts, some easier than others. His general uneasiness is due to the ambiguity of the task before him. This ambiguity and the fear of possible failure are more negatively reinforcing than his brooding over the family problem. It is therefore not surprising that he keeps finding excuses or distractions to avoid settling down to work.

According to our principle, the first step is for Prebyn to focus on the simpler of the two problems, the project, and temporarily to set aside the family difficulty. He then needs to divide the project into its parts, order these parts in terms of difficulty, and start with the easiest one. Analyzing his problem into its components and knowing where to start helps counteract his perception of the project as amorphous and overwhelming. His work on the easiest first item will in turn serve to distract him from the family problem. Although there is no guarantee of success at various stages, this technique at least maximizes the possibility of success and reward at every stage.

When Prebyn completes his project, he can turn to his family

problem, the more difficult of the two. At that point he will not be distracted by the uncertainties of an uncompleted project. His approach to the family problem would once again involve a gradual transition from the easy to the difficult steps. Division of both problems into parts of varying difficulty will also help Prebyn decide what kind of help to get and at which stage to seek it.

## COMPLEX PROBLEMS

In tackling the simple, limited interpersonal problems we all face from day to day we will probably find that one or the other of the techniques described in this book would probably serve effectively in each case. Very frequently even those who seek professional help can be assisted sufficiently with only a single technique. But sooner or later most of us encounter difficulties of greater complexity, more pervasive problems that we can't seem to cope with on such simple bases. One example of such a pervasive problem is the experience of a general malaise or discomfort without even knowing why.

There are several general guidelines for an approach to such complex situations, most of which have already been discussed in other contexts. The first step, of course, is the definition of the problem in terms of its various behavioral components. Such a definition would provide the details about (1) the kinds of social situations involved, (2) the specific behaviors of the participants, as identified through recurrent patterns in the various examples, (3) the duration of the problem, which reveals the rigidity of the behaviors involved, (4) the inadequacy associated with various component behaviors, (5) the reinforcers which may be maintaining each problem behavior, and (6) other reinforcers which can be used to change it. In other words, with our greater familiarity with reinforcement and conditioning techniques, we can now more readily pinpoint the relevant recurrent patterns in a problem situation. As we listen to a person describe various instances in which he encounters difficulty, we will be looking for the common patterns noted above.[1]

Another important guideline for dealing with complex problems is: The positively reinforcing results of a change must exceed its

[1] Several of the recently developed group therapy exercises (such as those used in "sensitivity" or "encounter" groups) provide interesting ways to define problems (3, 38). Identification of some of the preceding patterns is often obtained through role playing, written descriptions, or direct observations of group members in specially designed emotion-arousing situations. For example, two persons in the group might role-play for the others an angry mother's conversation with an adolescent who comes home at four in the morning.

negatively reinforcing consequences. Further, any changed behavior that becomes strongly positively reinforcing will be maintained longer than one that is less positively or even negatively reinforcing. Finally, the more rigid and long established a behavior, the more difficult it is to change, since successful change first requires an initial disorganization of the rigid behaviors and then their replacement with other, more reinforcing ones.

Let us briefly consider how these guidelines can be applied in therapy situations.

The therapist would first obtain a definition of the problem and then order the components using some of the procedures from desensitization or rehearsal. George Kelly's approach, for one, used rehearsal in tackling graded series of problems. He would sometimes write a character sketch which illustrated the patient's mode of behaving in a given situation but differed in some significant respects. He would request the patient to act out this character sketch in a number of situations which increasingly approximated the critical one, or he would modify the sketch to include greater and more difficult changes.

Various stages might involve the use of models for situations where the patient lacks coping skills and feels completely helpless. The therapist could either suggest the models himself or select one or two from those described as available by the patient. He would use his greater awareness of principles of change and of possible roles appropriate to a given situation and suggest several of these to the patient, who in turn would select one or more which feel most comfortable for him to try. When the patient tried these roles, he would first be expected to rehearse them in emotionally neutral situations and then gradually move on to try them in more emotionally arousing (real life) situations.

In the case of married couples, once again the therapist would obtain a detailed list of troublesome incidents with several illustrations of each, in order to define their difficulties vis-a-vis one another. He would also ask them to rate the problems in terms of difficulty. They could next consider how, in the case of the simplest problem, each party could alter his or her behavior to provide a greater degree of net reinforcement to the other.

These alternate behaviors could be identified by asking each to suggest ways in which he would prefer the other to behave. The more acceptable one of these ways would then be attempted. In this way, with some effort, each would gain a desired change in his

partner. The therapist's role would therefore consist of helping to identify compromise possibilities and clearly defining such compromises for each party.

The couple would then use appropriate techniques to try one set of changes for about a week. They would return and discuss these changes, modifying the ones that prove unworkable, or simply proceeding with a more difficult step. The therapy situation would thus become an arena for discussing the details of compromise which would gradually be carried over to everyday situations. Having discovered the techniques whereby workable changes in the behaviors of both partners could be defined and attempted, the couple would begin to rely less and less on the therapist.

As in the case of individual therapy, the negative effects of the effort required from each partner would be compensated by the positive gains obtained from changes in the other's behavior. One of the therapist's major contributions would be his assistance in identifying alternate behaviors which would maximize reward for both parties and in this way maintain their motivation at various stages.

It is seen then that behavior therapy is more a learning situation than a conventional therapist-patient relationship. Another of its novelties is that it allows the therapist to assume the role of consultant to parents, teachers, or nurses who, in relation to the children and patients involved, would do the bulk of the therapeutic work themselves.

In closing, we should reconsider the one most important way in which our approach differs from psychodynamic and common-sense views of social influence. Both psychodynamic and common-sense notions would suggest that change starts from within (attitudes, feelings, and beliefs) and proceeds outward (specific behaviors). One must change a feeling or belief in order to bring about any lasting change in behavior.

The present approach to social influence would emphasize more the opposite: if behaviors can be changed, and if those changes can be successfully maintained over a period of time, then attitudes, beliefs, and feelings will also change to become consistent with these new behaviors. Accordingly, we will end with E. Robert Jones' more eloquent statement:

*It is easier to act yourself into a new way of thinking than to think yourself into a new way of acting.*

# REFERENCES

1. Ayllon, T., and N. H. Azrin, *The Token Economy: A Motivational System for Therapy and Rehabilitation.* New York: Appleton-Century-Crofts, 1968.

2. Azrin, N. H., and W. C. Holz, "Punishment," in *Operant Behavior: Areas of Research and Application,* ed. W. K. Honig. New York: Appleton-Century-Crofts, 1966, pp. 380–446.

3. Bach, G. R., and P. Wyden, *The Intimate Enemy.* New York: William Morrow & Co., Inc., 1968.

4. Bachrach, A. J., ed., *Experimental Foundations of Clinical Psychology.* New York: Basic Books, Inc., Publishers, 1962.

5. Bandura, A., "Behavior Modification through Modeling Procedures," in *Research in Behavior Modification*, ed. L. Krasner and L. P. Ullmann. New York: Holt, Rinehart & Winston, Inc., 1965, pp. 310–40.

6. Bandura, A. *Principles of Behavior Modification.* New York: Holt, Rinehart and Winston, Inc., 1969.

7. Bandura, A., J. E. Grusec, and F. L. Menlove, "Vicarious Extinction of Avoidance Behavior," *Journal of Personality and Social Psychology*, 1967, 5, 16–23.

8. Bandura, A., and R. M. Walters, *Social Learning and Personality Development.* New York: Holt, Rinehart and Winston, Inc., 1963.

9. Beakel, Nancy G., and A. Mehrabian, "Inconsistent Communications and Psychopathology," *Journal of Abnormal Psychology*, 1969, 74, 126–30.

10. Bijou, S. W., and D. M. Baer, "Operant Methods in Child Behavior and Development," in *Operant Behavior: Areas of Research and Application*, ed. W. K. Honig. New York: Appleton-Century-Crofts, 1966, pp. 718–89.

11. Brady, J. V., "Operant Methodology and the Experimental Production of Altered Physiological States," in *Operant Behavior: Areas of Research and Application*, ed. W. K. Honig. New York: Appleton-Century-Crofts, 1966, pp. 609–33.

12. Buehler, R. E., G. R. Patterson, and J. M. Furniss, "The Reinforcement of Behaviour in Institutional Settings," *Behavior Research and Therapy*, 1966, 4, 157–67.

13. Byrne, D., "Attitudes and Attraction," in *Advances in Experimental Social Psychology*, ed. L. Berkowitz. New York: Academic Press, Inc., 1969, pp. 35–89.

14. Engel, B. T., and S. P. Hansen, "Operant Conditioning of Heart Rate Speeding," *Psychophysiology*, 1967, 3, 418–26.

15. Erikson, E. H., *Childhood and Society.* New York: W. W. Norton & Company, Inc., 1963.

16. Eysenck, H. J., ed., *Behavior Therapy and the Neuroses.* New York: The Macmillan Company, 1960.

17. Ferster, C. B., and B. F. Skinner, *Schedules of Reinforcement.* New York: Appleton-Century-Crofts, 1957.

18. Festinger, L., *A Theory of Cognitive Dissonance.* Evanston, Ill.: Row, Peterson, 1957.

19. Fleming, I., *From Russia with Love.* New York: The Macmillan Company, 1965.

20. Freud, S., *A General Introduction to Psychoanalysis.* New York: Doubleday & Company, Inc., 1935.

21. Guthrie, E. R., *The Psychology of Learning*. New York: Harper & Row, Publishers, 1935.

22. Hadley, C., *The Invasion from Mars*. New York: Torchbooks, 1938.

23. Haley, J., *Strategies of Psychotherapy*. New York: Grune and Stratton, Inc., 1963.

24. Hall, E. T., *The Hidden Dimension*. New York: Doubleday & Company, Inc., 1966.

25. Heckhausen, H., *The Anatomy of Achievement Motivation*. New York: Academic Press, Inc., 1967.

26. Hefferline, R. F., B. Keenan, and R. A. Harford, "Escape and Avoidance Conditioning in Human Subjects without Their Observation of the Response," *Science*, 1959, *130*, 1338–39.

27. Helson, H., "Adaptation-Level as a Basis for a Quantitative Theory of Frames of Reference," *Psychological Review*, 1948, *55*, 279–313.

28. Herrnstein, R. J., "Superstition: A Corollary of the Principles of Operant Conditioning," in *Operant Behavior: Areas of Research and Application*, ed. W. K. Honig. New York: Appleton-Century-Crofts, 1966, pp. 33–51.

29. Holt, R. R., "Forcible Indoctrination and Personality Change," in *Personality Change*, ed. P. Worchel and D. Byrne. New York: John Wiley & Sons, Inc., 1964, pp. 289–318.

30. Jacobson, E., *Progressive Relaxation*. Chicago: University of Chicago Press, 1938.

31. Keutzer, C. S., "Behavior Modification of Smoking: A Review, Analysis and Experimental Application with Focus on Subject Variables as Predictors of Treatment Outcome." Unpublished doctoral dissertation, University of Oregon, 1967.

32. Keutzer, Carolin S., E. Lichtenstein, and H. L. Mees, "Modification of Smoking Behavior: A Review," *Psychological Bulletin*, 1968, *70*, 520–33.

33. Krasner, L., "Studies of the Conditioning of Verbal Behavior," *Psychological Bulletin*, 1958, *55*, 148–70.

34. Lindner, R., *The Fifty Minute Hour*. New York: Rinehart, 1955.

35. Lovaas, O. I., B. Schaffer, and J. Q. Simmons, "Building Social Behavior in Autistic Children by Use of Electric Shock," *Journal of Experimental Research in Personality*, 1965, *1*, 99–109.

36. Lundin, R. W., *Personality: A Behavioral Analysis*. London: Collier-MacMillan, 1969.

37. Mahl, G. F., and G. Schulze, "Psychological Research in the Extralinguistic Area," in *Approaches to Semiotics*, ed. T. A. Sebeok, A. S. Hayes, and M. C. Bateson. The Hague: Mouton, 1964, pp. 51–124.

38. Malamud, D. I., and S. Machover, *Toward Self-understanding: Group*

*Techniques in Self-confrontation.* Springfield, Ill.: Charles C. Thomas Publisher, 1965.

39. Matarazzo, J. D., A. N. Wiens, and G. Saslow, "Studies in Interviewer Speech Behavior," in *Research in Behavior Modification*, ed. L. Krasner and U. P. Ullman. New York: Holt, Rinehart and Winston, Inc., 1965, pp. 179–210.

40. McClelland, D. C., *The Achieving Society.* Princeton, N.J.: D. Van Nostrand Co., Inc., 1961.

41. Mehrabian, A., *An Analysis of Personality Theories.* Englewood Cliffs, N.J.: Prentice-Hall, Inc., 1968.

42. Mehrabian, A., "Significance of Posture and Position in the Communication of Attitude and Status Relationships," *Psychological Bulletin*, 1969, *71*, 359–72.

43. Mehrabian, A., and Susan R. Ferris, "Inference of Attitudes from Nonverbal Communication in Two Channels," *Journal of Consulting Psychology*, 1967, *31*, 248–52.

44. Mehrabian, A., and H. Reed, "Factors Influencing Judgments of Psychopathology," *Psychological Reports*, 1969, *24*, 323–30.

45. Mehrabian, A., and M. Wiener, "Decoding of Inconsistent Communications," *Journal of Personality and Social Psychology*, 1967, *6*, 109–14.

46. Mischel, W., *Personality and Assessment.* New York: John Wiley & Sons, Inc., 1968.

47. Morse, W. H., "Intermittent Reinforcement," in *Operant Behavior: Areas of Research and Application*, ed. W. K. Honig. New York: Appleton-Century-Crofts, 1966, pp. 52–108.

48. Paul, G. L., *Insight vs. Desensitization in Psychotherapy.* Stanford, Calif.: Stanford University Press, 1966.

49. Piaget, J., *Psychology of Intelligence.* Paterson, N.J.: Littlefield, Adams, 1960.

50. Premack, D., "Reinforcement Theory," in *Nebraska Symposium on Motivation*, ed. D. Levine. Lincoln, Neb.: University of Nebraska Press, 1965, pp. 123–80.

51. Rapaport, D., "The Structure of Psychoanalytic Theory: A Systematizing Attempt," in *Psychology: A Study of a Science*, (Vol. 3), ed. S. Koch. New York: McGraw-Hill Book Company, 1959, pp. 55–183.

52. Rogers, C. R., *Client-Centered Therapy.* Boston: Houghton Mifflin Company, 1951.

53. Rosen, J. N., *Direct Analysis.* New York: Grune and Stratton, Inc., 1953.

54. Shostrom, E. L., "Group Therapy. Let the Buyer Beware," *Psychology Today*, 1969, *2*, 36–40.

55. Skinner, B. F., " 'Supersition' in the Pigeon," *Journal of Experimental Psychology*, 1948, *38*, 168–72.

56. Skinner, B. F., *Cumulative Record* (Enlarged ed.). New York: Appleton-Century-Crofts, 1961.

57. Stampfl, T. G., and D. J. Levis, "Essentials of Implosive Therapy: A Learning-theory-based Psychodynamic Behavioral Therapy," *Journal of Abnormal Psychology*, 1967, *72*, 496–503.

58. Terrace, H. S., "Stimulus Control," in *Operant Behavior: Areas of Research and Application*, ed. W. K. Honig. New York: Appleton-Century-Crofts, 1966, pp. 271–344.

59. Truax, C. B., "Reinforcement and Nonreinforcement in Rogerian Psychotherapy," *Journal of Abnormal Psychology*, 1966, *71*, 1–9.

60. Tyler, V. O., Jr., "Exploring the Use of Operant Techniques in the Rehabilitation of Delinquent Boys." Paper read at American Psychological Association, Chicago, September, 1965.

61. Ullmann, L. P., and L. Krasner, *A Psychological Approach to Abnormal Behavior*. Englewood Cliffs, N.J.: Prentice-Hall, Inc., 1969.

62. Watson, J. B., and Rosalie Rayner, "Conditioned Emotional Reactions," *Journal of Experimental Psychology*, 1920, *3*, 1–14.

63. Wiener, M., and A. Mehrabian, *Language within Language: Immediacy, A Channel in Verbal Communication*. New York: Appleton-Century-Crofts, 1968.

64. Williams, C. D., "The Elimination of Tantrum Behavior by Extinction Procedures," *Journal of Abnormal and Social Psychology*, 1959, *59*, 269.

65. Wolpe, J., *Psychotherapy by Reciprocal Inhibition*. Stanford, Calif.: Stanford University Press, 1958.

66. Wolpe, J., *The Practice of Behavior Therapy*. Elmsford, N.Y.: Pergamon Press, 1969.

# INDEX

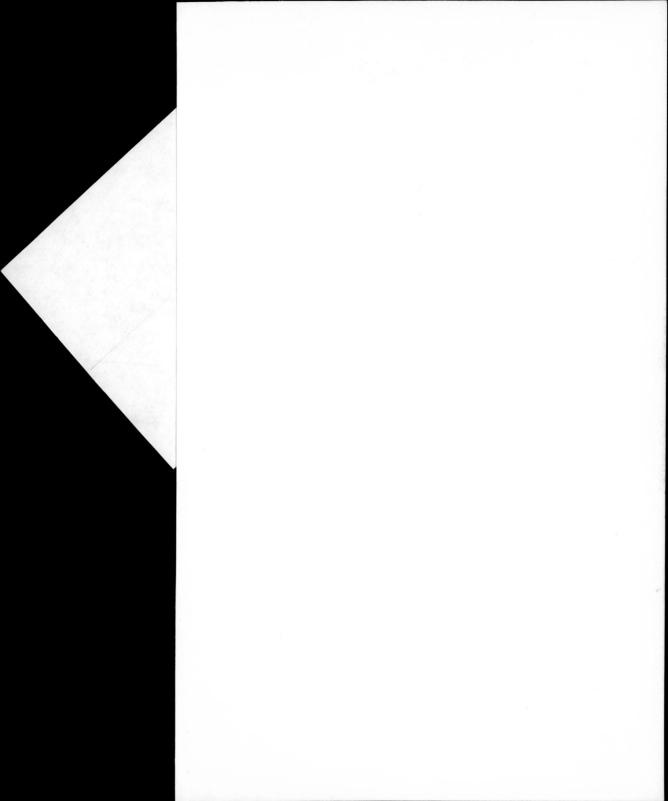